Photography

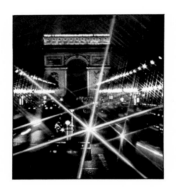

Ward Lock Limited · London

First published in Great Britain in 1980
by Ward Lock Limited,
82 Gower Street, London WC1 E 6EQ,
a Pentos Company

Designed and produced by
Grisewood and Dempsey Limited
Elsley Court, 20-22 Great Titchfield
Street, London W1 P 7AD.

Printed and bound in Italy.

British Library Cataloguing in Publication Data
Monk, Barry
 Photography—(Kingfisher leisure guides).
 1. Photography
 I. Title. II. Series

 770'.28 TR146

 ISBN 0-7063-6027-3

Author
Barry Monk

Editor
Norman Barrett

Consultant
Martin Hodder

Contents

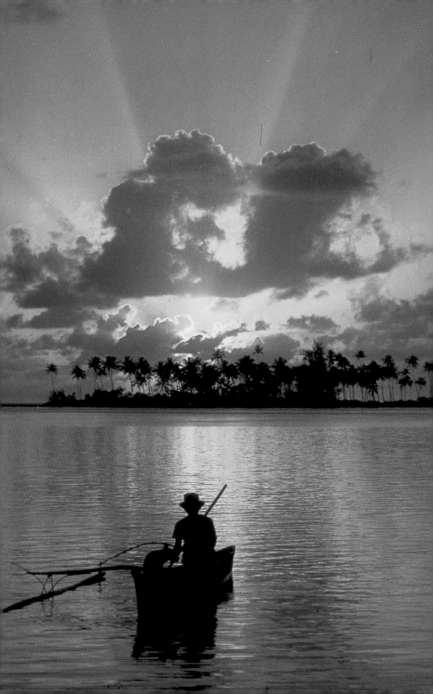

Introduction

Photography is an accepted part of our lives. Through it we can document all that is going on around us and capture instantaneous moments for permanent record. But it is also an art form, for even the humblest photographer with the crudest of cameras can create his own images. The word itself comes from the Greek, and means 'writing or drawing with light'.

It is easy to take photography for granted, yet it would be difficult to imagine our modern world without it. Books, magazines, newspapers, and journals all rely on photographs to illustrate stories. Indeed, photographs often tell their own stories – hence the saying, 'a picture speaks a thousand words'.

In the early pioneer days of photography, artists used the crude *camera obscura* to copy landscapes and other subjects. The later introduction of light-sensitive materials and simple cameras transformed photography into an activity for everyone. Millions of amateur photographers take photographs for pleasure. To them, photography is a creative and satisfying hobby or perhaps just a means of recording the interesting events of their lives.

Photography is also a profession, a mixture of skill, technique, and often of artistry. And it has its own specialist applications, as in medical work, in space, or beneath the sea, for example.

In recent years, camera development has relied more and more on the use of electronics. Yet, despite the increasing internal complexity of many of today's cameras, they are designed for easy use. Many include fully automatic exposure, and some have built-in flash and other convenient features. Some models even have automatic focusing, making it virtually impossible to take a picture that is not perfectly sharp.

Such technology helps to take some of the complications out of operating the camera, and allows the photographer to concentrate on the essential part of photography – taking pictures.

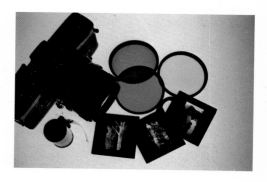

Left: The idyllic picture? The sun sets through a dramatic cloud formation and a lone boatman slowly ruffles the calm of the lake, with palms swaying in the distance. Shots like this require planning, patience...and not a little luck!
Right: Basic 35mm photography: camera, film, filters, and, of course, the pictures.

Right: A shot taken at a photographic equipment show with a 6mm Nikkor 'fish-eye' lens, an expensive item with limited applications.
Below: The remoteness of an old Scottish castle is beautifully captured. Sonia Halliday Photographs.
Opposite page, top: Fast ski-action – and fast camera work too.
Below left: Strength and character in this portrait of Lord Goodman. Patrick Lichfield.
Below right: Angler caught napping – an excellently composed photograph.

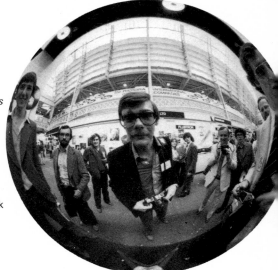

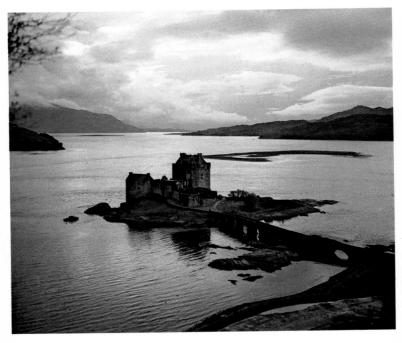

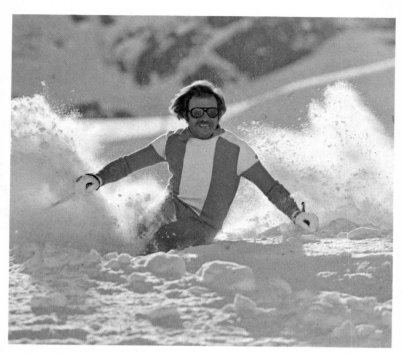

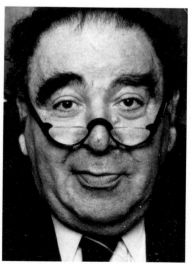

11

Above and right: A picture can be completely changed by some careful manipulation in the darkroom. In this case the original negative of the above photograph has been copied onto special 'line' film, which has then been enlarged to produce the grainy 'pen and ink' print on the right.
Alan McFaden.

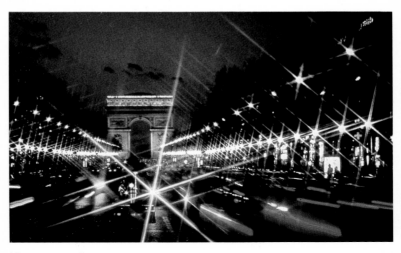

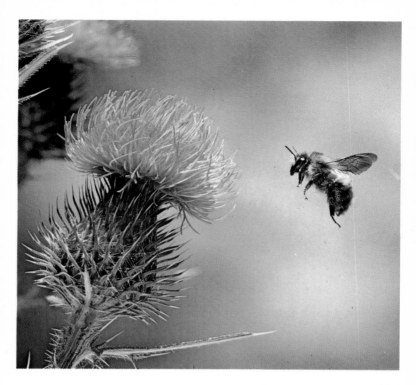

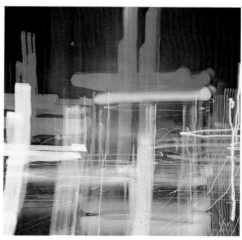

Left: Dramatic effects can be created with simple accessories. A 'star' filter was fitted over the lens for this shot, producing six-pointed flares for every point of light.

Above: In this fantastic close-up, the bee 'took its own picture' by crossing an infra-red beam which fired the camera. Stephen Dalton.

Right: Painting with the camera – a long exposure and camera movement created a surrealistic image from traffic lights: Sonia Halliday Photographs.

Basic Principles

Light is the basis of photography. Just as we need light to see the things around us, so we need it to take photographs.

Photography is a way of controlling light. And because light travels in straight lines, it is relatively easy to control. You can see this by observing shadows behind objects blocking light from the sun, or by redirecting light by means of a mirror.

Light is also the source of colours. White light is actually made up of several colours which we call the visible spectrum – this ranges from red to violet. The objects around us absorb some of these wavelengths and reflect others, so that we see them as colours. For instance, a tomato absorbs blue and green wavelengths, but reflects red – so we see it as red.

One crude way of capturing and controlling light is to use a pin-hole camera. Light is admitted through a tiny hole in this box-type camera and an image is formed inside. But as light travels in straight lines, the image appears upside-down, with light from the top part of the viewed object reaching the bottom part of the image (see diagram at bottom of page).

The image is rather dim and unclear in this type of camera because the hole has to be so small – if it were any larger the light rays would fan out and cause the image to be completely 'blurred'. So, in order to create a brighter and sharper image, we need a *lens*. This helps to gather in more light and converge the light rays, i.e. focus the image.

This basic principle of light control using a lens is applicable in all cameras. The light travels through the lens and reaches the film at the back of the camera. A shutter and lens diaphragm, or aperture, both regulate the amount of light reaching the film. But we will look more closely at shutters and lenses later on.

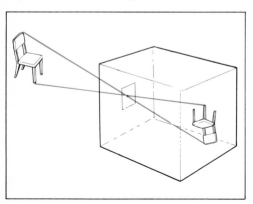

Left: The pin-hole camera shows the camera principle in its most basic form. Light enters the box through a tiny hole, forming a faint inverted image on a translucent screen.

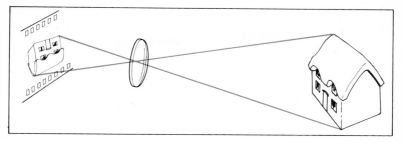

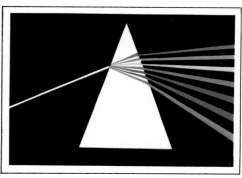

Above: The basic simple lens. When parallel rays of light strike the surface of the lens they come together at the focal point. *The distance between that point and the optical centre of the lens is the* focal length. *Right: White light is made up of the colours of the visible spectrum. This can be seen when white light is passed through a prism.*

The Birth of Photography

Photography has been with us for only about 150 years, although the actual principle of cameras dates back much further. The *camera obscura*, literally 'dark chamber', was a portable room widely used by artists in the 1600s for making sketches. Light, entering the room through a tiny hole in one wall, projected, on the opposite wall, an inverted image of the view outside.

But it was the combination of optics and chemistry that later created photography. In 1826, Frenchman Joseph Nicéphore Niepce used a coated pewter plate to produce the first *camera obscura* photograph. It took eight hours' exposure to record the image – a view from his bedroom.

In 1839, Niepce's former partner, Louis Daguerre, invented the *daguerreotype*, a silver-coated plate on which an image could be formed and fixed. Then, in 1841, British inventor William Fox Talbot patented his *calotype* process, which produced a negative.

Photography continued to move forward and, in 1888, American manufacturer George Eastman introduced the Kodak camera, supplied loaded with film. After taking the pictures, the photographer sent the camera and film back to Kodak, who returned prints – and a newly loaded camera. 'You press the button, we do the rest' was the Kodak slogan. Photography had at last been made practical for amateurs – and it has been that way ever since.

Cameras

There are many different camera types available, but most cameras fall into two categories: *reflex* and *non-reflex*. These two terms refer to the design of the viewing system in the camera. Different camera types may also be categorized by the size of film they take.

A *non-reflex* has what is called a *direct-vision* viewfinder for viewing, framing, and (sometimes) focusing on the subject. Models that come into this category include simple 110 and 126 pocket cameras, as well as

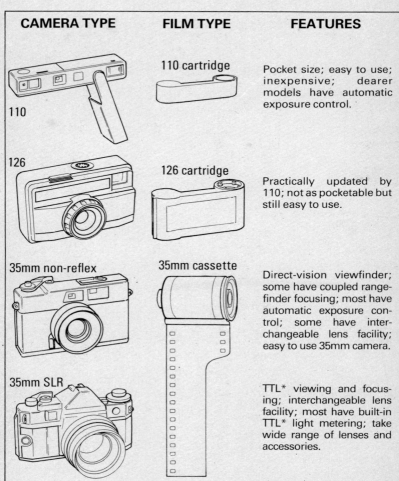

CAMERA TYPE	FILM TYPE	FEATURES
110	110 cartridge	Pocket size; easy to use; inexpensive; dearer models have automatic exposure control.
126	126 cartridge	Practically updated by 110; not as pocketable but still easy to use.
35mm non-reflex	35mm cassette	Direct-vision viewfinder; some have coupled range-finder focusing; most have automatic exposure control; some have interchangeable lens facility; easy to use 35mm camera.
35mm SLR		TTL* viewing and focusing; interchangeable lens facility; most have built-in TTL* light metering; take wide range of lenses and accessories.

35mm non-reflex or 'compact' cameras.

A *reflex* allows viewing and focusing of the subject through-the-lens (TTL) of the camera. This is made possible by a mirror-and-prism system inside the camera. In this category are 35mm single-lens reflex (SLR) cameras, large-format roll film SLRs, and twin-lens reflex (TLR) cameras.

There are also specialized cameras, such as *instant picture* cameras, which can produce a finished print from the camera within minutes, and *studio view* cameras, used by professionals for high-quality work.

FEATURES	FILM TYPE	CAMERA TYPE
Features two lenses (viewing and 'taking'); few models available; interchangeable lenses and accessories on some.	Roll film	TLR
TTL* viewing and focusing; some have built-in TTL* light metering; wide range of lenses and accessories; ideal studio camera.		Large-format SLR
Large bellows camera; used mainly for professional high-quality work.	Sheet film	Studio view
Most produce finished print within minutes; convenient and easy to use.	Instant film	Instant picture

*TTL=through-the-lens.

35mm Direct-Vision

This type of camera goes under several different names – direct-vision, non-reflex, rangefinder – but, nowadays, it is more commonly called a 35mm 'compact' camera.

The 35mm compact is designed for ease of use. Most models are small, easily portable, and, perhaps even more important, easy to operate. Basically, the 35mm compact has the same 'point and shoot' simplicity as a 110 pocket camera, but is far more versatile.

Automatic Exposure

Most compacts have what is called *fully automatic exposure control*. A tiny light-reading cell measures the amount of light available to take the picture and automatically sets the shutter speed and lens aperture. The result should be a perfectly exposed picture – without fuss.

You first set the film speed for whatever film you are using – read

this off the film box and set on the camera's film speed dial (this is marked in ASA numbers). Then all you have to do is:

1. Compose the picture in the camera's viewfinder.
2. Set the focusing control (around the lens).
3. Shoot!

Many photographers like the freedom to control either the shutter speed or the lens aperture manually, and there are non-automatic models available that allow this.

Rangefinder Focusing

This feature, found in many compacts, is a simple focusing aid that helps the photographer to take sharper pictures. Inside a small central area of the camera viewfinder, two separate images of the subject can be seen. You turn the lens-focusing control until the images are superimposed, and the subject is then in correct focus.

Most 35mm direct-vision cameras are sophisticated, yet easy to use.

The Konica C35AF features autofocusing and flash.

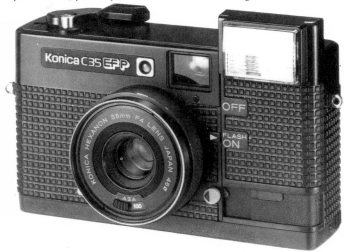

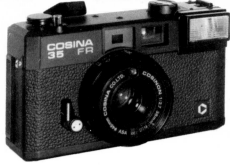

Some 35mm compacts, such as the Cosina (right), feature rangefinder focusing. Two separate images, seen in the viewfinder (top), superimpose when the subject is correctly focused (above).

Compacts without rangefinder focusing usually have some other kind of focusing aid. On many models (even rangefinders) the focusing distance is marked on a scale (in feet and/or metres) round the lens. You measure, or judge, how far away the subject is, and set the distance on the focusing control. Alternatively, some compacts have *focusing symbols* marked on the lens – a single figure for a portrait (about 1m or 3ft), two figures for a small group (about 1.5m or 5ft), and a mountain symbol (infinity) for distance shots. In some cases, there are also symbols in the viewfinder.

Other Features

A useful feature in many 35mm compacts is *built-in flash*, which is usually linked to the camera's automatic exposure system. One of the latest refinements is *automatic focusing*. Cameras with this facility have a tiny module inside that 'senses' how far away the subject is and sets the lens-focusing control automatically, just a split-second before the picture is taken. Most compacts have a fixed lens. But some makes, such as the Leica, have

an *interchangeable lens* facility. A special adjustable viewfinder has to be used with this system.

Viewing system

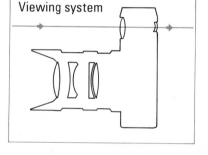

35mm Direct Vision

Pros
Compact size
Automatic exposure
Simple focusing
Can take filters
Ideal 'all-round' camera
Can produce better-quality results than 110 cameras

Cons
Lens cannot be changed (except some models)
Separate viewfinder does not always allow perfect framing
Very few accessories available
Not as versatile as 35mm reflex

35mm Single-Lens Reflex (SLR)

The 35mm SLR is the most sophisticated and versatile type of camera available, and is often the 'heart' of a complete camera system. Most SLRs have the same basic features. These include:

Interchangeable lenses. The SLR standard, or normal, lens can be replaced with another type of lens (wide-angle, telephoto, etc.).

Through-the-lens (TTL) viewing and focusing. The 35mm SLR incorporates viewing and focusing through the lens of the camera. This is made possible by a mirror-and-prism arrangement inside the camera. Light entering the lens is reflected off a small mirror (set at an angle of 45°), up through a focusing screen to a small five-sided prism (called a pentaprism), and out through the viewfinder eyepiece.

The image can be seen on the focusing screen inside the viewfinder the right way up and right way round. This TTL system has two distinct advantages: accurate framing (the image appears on the film exactly as it is seen in the viewfinder) and accurate focusing (you can see clearly whether the subject is in correct focus).

TTL Metering. Most SLRs have a built-in TTL light-metering system. This allows a light reading to be taken from the subject without the need for a separate hand-held light meter. A small, light-sensitive cell (usually CdS or silicon) inside the camera measures the light level, and exposure information then appears in the viewfinder.

Exactly how the metering in the camera operates depends on whether

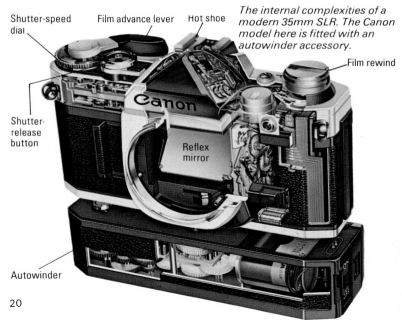

The internal complexities of a modern 35mm SLR. The Canon model here is fitted with an autowinder accessory.

Shutter-speed dial

Film advance lever

Hot shoe

Film rewind

Shutter-release button

Reflex mirror

Autowinder

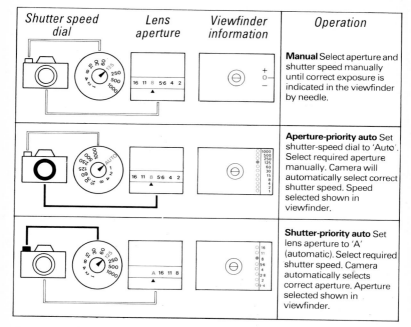

Shutter speed dial	Lens aperture	Viewfinder information	Operation
			Manual Select aperture and shutter speed manually until correct exposure is indicated in the viewfinder by needle.
			Aperture-priority auto Set shutter-speed dial to 'Auto'. Select required aperture manually. Camera will automatically select correct shutter speed. Speed selected shown in viewfinder.
			Shutter-priority auto Set lens aperture to 'A' (automatic). Select required shutter speed. Camera automatically selects correct aperture. Aperture selected shown in viewfinder.

the camera is manual or automatic (see the diagrams above).

SLR Operation

When you press the shutter-release button on an SLR, the camera goes through a complex, but co-ordinated, sequence as the picture is taken. First, the small 45° mirror flips up, and the diaphragm in the lens closes to the preselected aperture. Then the shutter opens, allowing the light entering through the lens to reach and expose the film.

After exposure, the shutter closes, the mirror drops back down to the 45° position, and the lens diaphragm reopens to allow further viewing for the next shot. During the instant of exposure, however, the viewfinder image is blanked off until the mirror drops again.

Viewing system

35mm SLR (most models)

Pros
TTL viewing, focusing, metering
Interchangeable lenses
Range of accessories
Good 'system' camera

Cons
Some models awkward to handle
Electronic models can be fragile
Dust may enter camera during lens changing
Image loss as mirror 'flips up'

Twin-Lens Reflex (TLR)

The twin-lens reflex (TLR) has two separate lenses – the top one for viewing and focusing, the other for exposing the film. The viewing lens reflects the image onto a square focusing screen via a single 45° mirror. There is no prism arrangement inside the TLR, so the image appears on the screen in reverse, but the right way up. The bottom, 'taking', lens admits light direct to the film via a bladed-leaf shutter.

The problem with having two separate viewing and taking lenses in the same camera is the slightly different viewpoint between them – this is known as *parallax* error. The problem can be overcome by raising the 'taking' lens to the same level as the 'viewing' lens before shooting.

Most TLRs have a waist-level viewfinder. The camera's viewfinder hood flips up and you look down into the viewfinder screen. Some models also have a built-in magnifying lens, so the camera can be raised to the eye-level position for more critical focusing. During the focusing operation the two lenses in the camera are moved at the same time by a small knob on the side of the camera. One advantage of the TLR

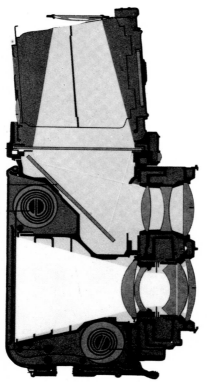

Left: A twin-lens reflex camera features separate 'viewing' and 'taking' lenses.
Below: Parallax error is corrected by a slight adjustment of the camera.

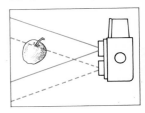

viewing system is that the viewing image is never 'blanked-off', even at the moment of exposure. So when taking a portrait, for example, you can see if the subject's eyes close as you press the shutter release.

Most TLRs have fixed lenses, and a few have built-in light meters. The Mamiyaflex has interchangeable lenses, but extra lenses are expensive because you are buying two at a time. In TLRs with built-in light meters, the light-reading cells are usually separate from the camera lens and do not take a TTL reading.

Large-Format SLR

This type of camera has the same basic design features as the 35mm SLR, but uses the larger-format 120 roll film. The extra quality offered, together with its ability to accept many specialist accessories, makes it popular with professionals.

The large SLR has several useful features. Most have an inter-changeable-back facility, enabling

<table>
<tr><td colspan="2">TLR (most models)</td></tr>
<tr><td colspan="2">Pros</td></tr>
<tr><td colspan="2">Takes large-format film</td></tr>
<tr><td colspan="2">Separate viewing lens ensures no image loss during exposure</td></tr>
<tr><td colspan="2">Mechanically simpler than 35mm SLR</td></tr>
<tr><td colspan="2">Ideal studio or portrait camera</td></tr>
<tr><td colspan="2">Cons</td></tr>
<tr><td colspan="2">Image reversed in viewfinder</td></tr>
<tr><td colspan="2">Most TLRs awkward to handle</td></tr>
<tr><td colspan="2">Possible parallax error</td></tr>
<tr><td colspan="2">Fewer shots per film on 120 than 35mm</td></tr>
</table>

the film to be removed half-way through and replaced with a different film back – useful if you want to shoot black and white and colour alternately. Some large SLRs also take a special Polaroid back, so that an instant picture can be taken of the scene (to judge lighting, exposure, etc.) before a conventional film is used.

On models such as the Hasselblad, the film format may also be changed.

Large-Format SLR

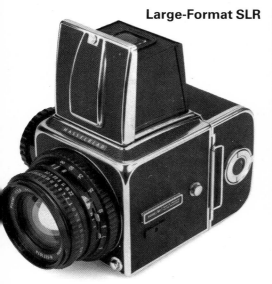

Pros
TTL viewing, focusing and metering (special attachment sometimes required)
Roll-film format offers better quality than 35mm
Interchangeable lenses
Range of accessories
Ideal professional 'system' camera

Cons
More bulky and awkward than 35mm SLR
Lenses and accessories expensive
Fewer shots per film on 120 than 35mm

Studio View Camera

The view camera has basically the same design as the old plate cameras first used in the early days of photography.

Nowadays, they are made of metal instead of wood, with a lens (and built-in leaf shutter) linked to an image-focusing screen at the back of the camera, via an extending bellows. The image appears upside-down and is usually so dim that the photographer still has to view it from under a black cloak.

View cameras use sheet film, the size of which depends on the size of the camera. But most are 4×5in (10×12.5cm), which is loaded into special holders that take two sheets at a time. Because of the size of the film, very high-quality results are possible. For this reason, the view camera is popular with studio photographers.

It is also ideal for use in architectural or similar technical work, because the front and back ends of the camera can be tilted and adjusted to vary the image shape and perspective.

However, the bulkiness of the view camera makes it somewhat difficult to use on location and it always has to be supported on a good tripod.

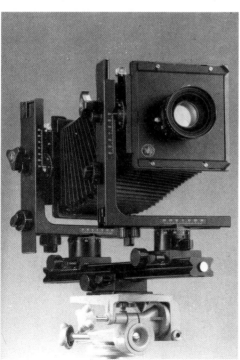

View Camera (most models)

Pros

Takes large sheet film for high-quality results

Bellows extension allows close-focusing

Interchangeable lenses and backs

Both ends of camera can be tilted or turned

One sheet can be exposed and processed before further film is exposed

Ideal for studio or other technical work

Cons

Very bulky and slow to use

Film holders must be loaded in dark before use

Dim viewing image

Tripod essential

Pocket Cameras

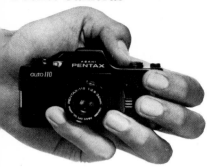

Most 110 pocket-size cameras are small, easy to carry, easy to use and, perhaps most important, easy to load. They take a small 110 film cartridge, which slips easily into the camera.

The cheaper type of 110 camera is very basic, featuring a fixed lens, a direct-vision viewfinder, and shutter-release button. All you have to do is 'point and shoot'.

But results with this kind of simple camera can be somewhat 'hit or miss' affairs, and it is often worth paying more for a few extra facilities. These may include a focusing control, usually a small sliding switch marked with a distance scale, or focusing symbols, and an exposure control, another switch, often marked with small weather symbols. Many 110s also have automatic exposure control, 'close-up' or 'tele' lenses (lenses that slide over the normal camera lens), and built-in flash.

Modern 110s can use fast films, and this enables you to take pictures in a wider variety of situations, even in quite low light. Most of these cameras also have a fast shutter speed, which makes it easier to photograph moving objects without getting blurred results. The problem of camera shake is also alleviated on some models by a built-in handle-grip, which folds down as a protective case when the camera is not in use.

110 SLRs

The 110 SLR is a scaled-down version of the 35mm SLR – but it is a lot smaller, lighter, more pocketable, and sometimes easier to use. And, of course, it takes the 110 'pop-in' film cartridge.

The Pentax Auto 110 SLR is a complete system camera with a range of small lenses, filters, and other accessories. The camera can be

Top: Pocket cameras have become more sophisticated in recent years. The Pentax Auto 110 features automatic exposure control and can be fitted with different lenses and accessories. Right: The Kodak Ektra features a fast shutter speed (1/125sec), making it easier to capture a moving subject. The steadying handle folds over as a case.

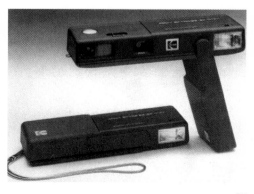

Left: The Minolta 110 Auto Zoom SLR was one of the first 110 cameras to feature a reflex viewing system. The non-interchangeable lens has a zoom facility (25-50mm) and a close-up 'macro' setting.

bought on its own, or as a kit with the accessories.

The Minolta Auto Zoom 110 SLR is slightly larger and heavier, and does not have a facility for changing lenses. But it has a built-in zoom lens, which can be adjusted to photograph subjects near and far away.

126 Cameras

Most 126 cameras have been largely replaced by the smaller 110 models, but there are still some around. They take the larger 126 cartridge film, and although they are simple and easy to use, they are bulkier than 110 models.

Instant-Picture Cameras

Instant-picture cameras offer one big advantage over most other cameras – they can produce a finished print within minutes. There are only a few instant-picture cameras, each taking a specific type of instant film.

Polaroid 'peel-apart' film. Cameras using this film are the direct-vision type and are easy to operate. Most have automatic exposure control. Depending on the model, two film formats are available, and the film comes in easy-to-load packs, which produce up to eight prints.

After each exposure, you pull two

Pocket Camera (most models)

Pros
Light and pocketable
Easy to operate
Takes easy-to-load cartridge (110 or 126 size)

Cons
Maximum 20 exposures per film
Quality not as good as 35mm, particularly when enlarged
Fewer films available in 110 and 126 sizes

special tabs out of the camera, drawing the negative/positive paper in the film through special rollers inside the camera. These rollers 'break' a small amount of jellied chemical inside the film and spread it over the two materials evenly, as the film is pulled out.

After about a minute, the two sides can be peeled apart to give a finished print and disposable negative (on one type of film the negative can be kept to make further prints).

Polaroid SX-70. This is a 'sealed' film and requires no peeling apart. The print comes out pale green, and begins to develop in seconds. The green cast slowly disappears, and the final colour image is complete within

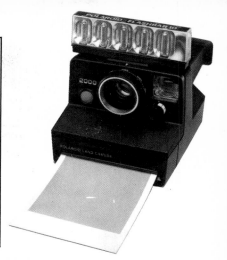

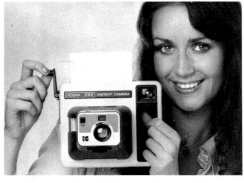

Two leading instant-picture cameras: On the Polaroid SX-70 (above), a motor inside the camera ejects a sealed print after the picture has been taken – the image gradually appears within minutes. On the Kodak EK2 (left), the sealed print is ejected by a hand-crank on the camera. Both cameras use their own film (SX-70 and PR10 respectively).

a few minutes. It is more fade-resistant than the peel-apart type, and not as messy. There are 10 exposures per pack. There are both reflex and non-reflex SX-70 cameras, and even a model – the Sonar Auto-focus – that features automatic focusing (by sound waves).

Viewing and focusing on SX-70s is TTL, and the exposure control automatic. If the print comes out too light or dark, a small control enables you to make the next print lighter or darker. A small motor automatically ejects the print out through the front of the camera and the image gradually appears.

Kodak EK. Kodak instant cameras feature a slightly different exposure method and their own type of film. They have direct-vision viewfinders with special focusing aids, including a head-size circle.

Inside each camera is a double-reflex arrangement where two mirrors are used to direct light onto the film. The cameras have automatic exposure control (with lighten/darken control) and at least one has motorized print ejection.

Accessories

Walk into any camera shop and you will probably be confronted with not only a lot of cameras but also a vast array of camera accessories. And even if you could buy them all, you probably would not find time to use each one. So the answer is, be selective.

The accessories you buy will depend to a great extent on the type of camera you own. A 35mm SLR, for example, can usually accept more accessories than a 35mm compact. But whatever your camera, decide what you think are the essential items that you will use straight away, and leave non-essential items to be purchased when and if you need them.

Your choice will probably depend on two factors: your interests and your budget.

Interests. Think carefully about the type of photography you are most interested in pursuing – landscape, portraiture, wildlife, sport, or whatever. Then tailor the choice of accessories to those specific needs. If your interests are more general and you expect to tackle a variety of subjects, think about buying the equipment that will be useful in as many areas as possible. This is particularly important when purchasing expensive items such as extra lenses.

Budget. Photography does not have to be an expensive hobby, but it can be if you keep buying accessories that you never use. When starting out, you can acquire a few inexpensive items such as a lens hood, a blower brush (for cleaning the lens and inside of your camera),

and a couple of filters. Then, as your photography develops, you can think about buying more-expensive gadgets such as a tripod and a flashgun.

And if you like to travel especially light, you don't even have to use a gadget bag. All you need is a compact camera with built-in flash, and a little case that fits on your camera strap to hold a few odds and ends.

Key to photograph opposite: (1) Gadget bag, (2) Tripod, (3) Spare film, (4) Flashgun, (5) Extra lenses, (6) Lens hoods, (7) Extension tubes, (8) Miniature screwdrivers, (9) Filters, (10) Spare camera batteries, (11) Blower brush, (12) Cable release.

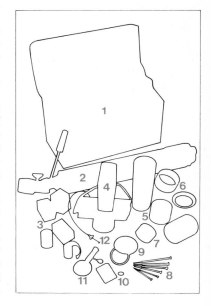

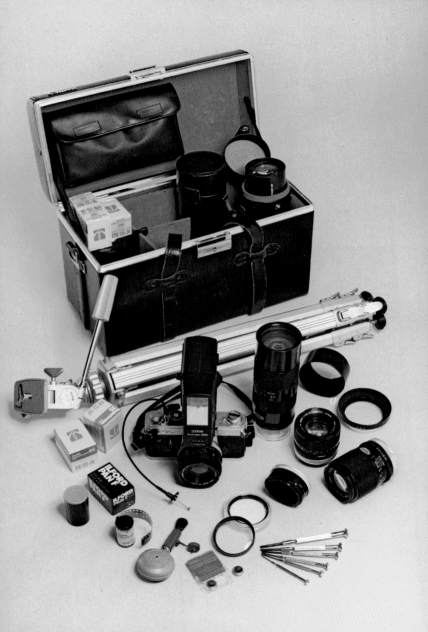

Lenses

The modern camera lens is made up of several pieces of optical glass, called *elements*. There are basically two types of element – converging and diverging – each bending light in a different way.

to prevent reflections inside the lens from interfering with image quality.

The maximum aperture and focal length of a lens are always indicated on it, and are a guide to its versatility, although not necessarily its quality.

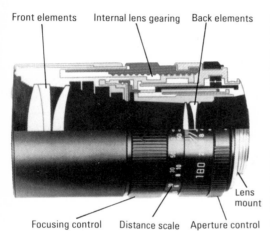

Front elements Internal lens gearing Back elements

Focusing control Distance scale Aperture control

Lens mount

Left: A cut-away picture showing the internal workings of a modern lens. Small gearing threads move some of the glass elements when the focusing ring is turned.

Below: Using a zoom lens, the photographer has 'zoomed-in' during the brief moment of exposure, causing the 'streaking' effect around the athlete.

On its own, a converging element will form an image on film. But, because of the lens curvature, this image will be sharper at the centre than at the edges. However, if the converging lens is combined with a weaker diverging lens, this defect can be corrected.

The lens designer uses this principle when creating the *compound lens*. With the help now of modern computer design technology, a collection of different elements are grouped together in a precise way to make a compound lens that will give a high-quality image. Many of the elements are also given an 'anti-flare' coating

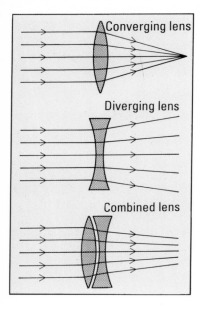

Top: Converging lens. Middle: Diverging lens. Bottom: Lens designers use carefully constructed combinations of converging and diverging lenses in modern camera lenses.

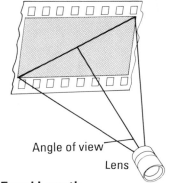

Angle of view

Lens

Focal Length

The focal length of a lens is the distance from the lens to the focal plane (the plane at which the lens forms a sharp image when correctly focused). A 'normal' camera lens is designed to have a focal length equal to the diagonal of the negative, or image, area (see diagram).

A lens with a shorter focal length than 'normal' is called a *wide-angle*, larger than 'normal' a *telephoto*, and one with an adjustable focal length a *zoom*.

Lens Controls

Most lenses have two controls – a focusing ring and an aperture ring. The focusing ring actually moves some of the elements in the lens to and fro so that subjects at varying distances may be sharply focused.

The aperture ring is used to adjust the f/stops on the lens – the lower the f/number, the larger the aperture.

Other information may include a depth-of-field scale and an infra-red focusing mark (for use with infra-red film).

On some cameras, a shutter-speed ring may also be located just behind the lens controls.

The selection of pictures here were all taken from the same point with different focal length lenses. The 50mm lens is the standard lens found on most 35mm SLR cameras. The 28 and 35mm are wide-angle lenses, while the 80, 135, 200, and 300mm are telephoto lenses. Note how the background gradually becomes insignificant as the focal length increases.

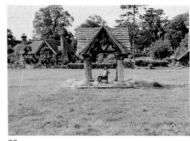

28mm

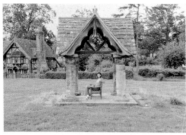

35mm

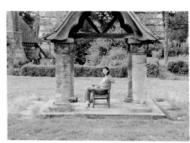

50mm

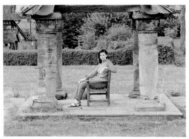

80mm

135mm

200mm

300mm

Use of lenses. *With so many different types of lenses available, the newcomer to photography may well ask: 'Which ones should I buy?'. The simple answer is – choose what you really need. As photographers, we all have particular interests. There are subjects that we want to photograph more than others. For example, for landscape work, a* wide-angle *lens may be a first choice – the shot on the right was taken with a 28mm lens. When taking sports, you cannot always get close to the action. The football shot below was taken with a* telephoto *lens.*

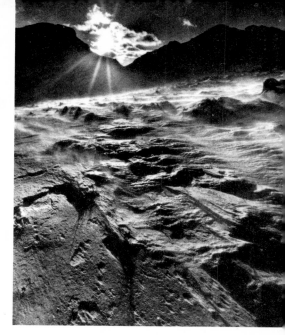

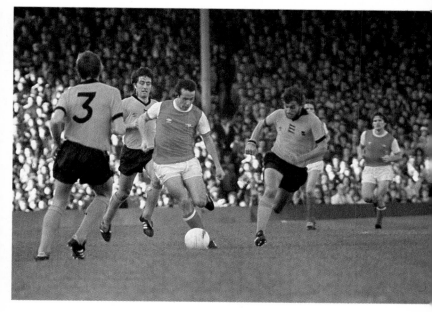

Using the Camera

When you buy a new camera, it obviously pays to familiarize yourself with it. So the first thing to do is READ THE INSTRUCTION BOOKLET. This will tell you all about the various camera controls, how to operate them – and how *not* to operate them. It will explain how to load and unload the camera, and how to fit and use camera accessories such as flash and filter.

Having a basic knowledge of how the camera works is half the battle in photography, so before running off a reel of film, take time to handle the camera. This is also a good opportunity to check for faults. Test shutter speeds approximately and lens aperture controls (if possible) and the film advance mechanism. You might try putting an old film through the camera. If you encounter problems, take the camera back to the dealer.

Above: Holding the camera in this position should be fine for most shots. The camera is gripped firmly with three fingers of the right hand, leaving the forefinger and thumb to operate the shutter release button and film wind-on lever, respectively. The left hand adds extra support, with the fingers operating the lens focusing and aperture controls. Stand erect, with legs slightly apart and elbows tucked in. Above right: For some shots it is necessary to hold the camera in the upright position. Bring the right side of the camera up and support the body with the left palm, leaving the fingers free to adjust the lens.

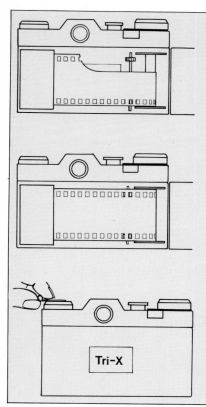

Loading the Film

The basic steps of loading a film sometimes cause more problems for many photographers than actually taking pictures. At best, it can be a fiddly operation until you have had a little practice and, if the film is not loaded correctly, it can sometimes jam in the camera or even fail to go through — leaving the bewildered photographer with a set of blank pictures.

Here are the basic steps to follow:

1. Open the camera back. Remove any dust or grit with a blower brush.

2. Insert the cassette.

3. Insert the film 'leader' into the slots in the take-up spool.

4. Run *both* sides of the film over the sprockets by advancing the film advance lever (firing the shutter between each advance).

5. Close the camera back. Turn the film rewind lever until you feel the film tighten in the cassette.

6. Advance the film a couple of times to the first frame (indicated by frame counter). On most cameras, the film rewind mechanism will turn, indicating that the film is going through the camera correctly.

Left: In situations where a slow shutter speed is necessary, or perhaps in a strong wind, try to find some extra support. Lean against a wall, a tree, a lamp-post, or any other sturdy surface that will prevent you shaking the camera.
Right: It is difficult to support a heavy lens, if you do not have a tripod. Try resting the lens on a sturdy surface, or lie on the ground and support it with one hand.

Focusing

Blurred or 'fuzzy' pictures are usually the result of inaccurate focusing. The remedy usually depends on the type of camera you have. If it is a simple 110 with a fixed-focus lens, no adjustment to focusing can be made. But the lens in this type of camera is designed to provide reasonably sharp pictures at most distances beyond about 1 metre (3ft), so be careful not to go any closer than that. (Fuzzy pictures may also be caused by camera shake or movement.)

Many cameras are focused simply by judging subject distance, and setting this on the lens. To avoid human error with such cameras, you might find it possible to use an extendable tape measure, or pace out sub-

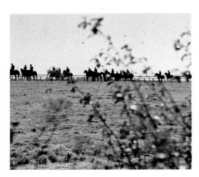

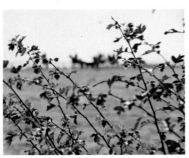

ject distances. On the other hand, with a little practice, judging distances correctly should not be too difficult.

If the camera has rangefinder or TTL focusing, you can see in the viewfinder whether the subject is in focus. But sometimes it is possible to focus on the wrong point – in a close-up portrait, for instance, it is best to focus on the subject's eyes, because they are the dominant facial feature. If you focus on the nose, the eyes may be out of focus and the portrait will look wrong.

To emphasize a certain part of a picture, you can use what is called *selective focusing*. For example, you might deliberately focus on an object in the foreground so that it stands out against the out-of-focus background.

You can also use the aperture to affect focusing, because *depth-of-field* determines how much of the picture, behind and in front of the point focused on, will be sharp (see page 38).

Focusing Aids
In some camera viewfinders, there are special focusing aids to help the photographer get sharp pictures.

Many 35mm compacts are

The two shots here, taken from an identical viewpoint, show how selective focusing (i.e. the part of the subject area you focus on) can change the impact of a picture. In the first shot (top) the lens was focused on the horses in the far distance. The resulting picture is a general view, with the branches adding some foreground interest. In the other shot, the lens was focused on the leaves, with the horses forming a hazy backdrop.

In a portrait shot, focus on the eyes for maximum sharpness and detail.

equipped with a *rangefinder*. With this device, when the two separate images seen in the viewfinder are superimposed, that part of the picture is in focus.

Most SLRs have a dual system – the *split-image/microprism*. The split-image shows the subject split in two parts, which come together when the subject is in focus. Some subjects lend themselves more readily to the other device, a small circle of microprisms (surrounding the split-image spot), which shows a fuzzy image when it is out of focus, but a clear image when it is sharp.

Depth of Focus
Depth of focus is the distance that the film plane can be moved while still retaining a sharp image, and without the need to refocus the lens. This is important, for example, on a large-format view camera where the back (the film plane) is adjustable. Depth of focus extends the same distance in front of and behind the point focused on.

Using Apertures

The aperture is the opening of the lens diaphragm, and is denoted in *f*/numbers. The aperture has two basic functions: it controls the level of light entering the camera and it controls the depth of field.

The lens diaphragm is made up of several blades, which open or close as the lens aperture ring is adjusted. Opening the aperture enables more light to reach the film, so it is important in controlling exposure.

Depth of Field

When a lens is focused on a certain point, an area in front of and behind

Left: A wide aperture may be used to throw the background out of focus. This shot was taken with a long-focus lens (200mm), making the background even more insignificant. This technique helps to emphasize, or single out, the main subject.

Opposite page: The three diagrams show the actual depth of field at three different apertures. In each case, the lens is focused on the subject at 3 metres (10ft), but the area of sharpness in front of, and behind, the subject varies as the lens aperture is changed.

Illustrating depth of field. The unbroken line shows the distance focused on while the white areas behind and in front of it show the amount of acceptable sharpness. Anything in the grey areas would be out of focus.

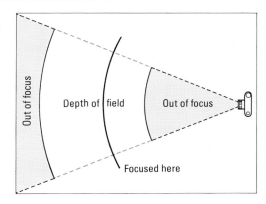

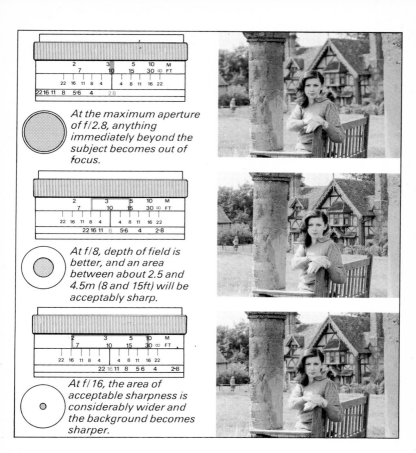

At the maximum aperture of f/2.8, anything immediately beyond the subject becomes out of focus.

At f/8, depth of field is better, and an area between about 2.5 and 4.5m (8 and 15ft) will be acceptably sharp.

At f/16, the area of acceptable sharpness is considerably wider and the background becomes sharper.

that point may also be acceptably sharp. The distance between the nearest and farthest point that will be acceptably sharp is known as the *depth of field.*

Depth of field increases as the lens aperture is stopped down (made smaller). In general, depth of field extends one-third in front and two-thirds behind the point focused on. And the farther the subject is from the camera, the greater the depth of field.

You can use depth of field to con-

trol sharpness. For example, if you focus the lens on a foreground subject (say at 3m [10ft]), you can make the background completely out of focus by using a wide aperture (to minimize depth of field).

Depth of field also varies between lenses. As a rule, the shorter the focal length of the lens, the greater is the depth of field. Thus, small-format cameras (such as the 110s) with short-focal-length lenses, may often give sharper results than much longer lenses on larger cameras.

Using Shutter Speeds

Shutter speed is the time taken for the camera shutter to open and close. The shutter speed not only captures the movement of the subject, but also controls the amount of light reaching the film.

On most simple cameras the shutter speed is fixed, usually at 1/30 or 1/60 sec. This speed is slow enough to admit sufficient light to the film for an exposure under average conditions, but fast enough to 'freeze' a moving subject and allow for normal camera movement.

If your camera has variable shutter speeds, you can be selective about the speed you choose and thus exercise some creative control over the pictures. You have, for example, a choice when photographing moving objects. For a horse race, say, you can choose either a fast shutter speed (say 1/1,000 sec) to freeze the action on film, or use a slower speed (say 1/30 sec) so that the image is slightly blurred, thus creating a suggestion of movement – an artistic picture rather than an accurate one.

In the latter situation, a technique called *panning* can be used. This involves following the subject (horses), keeping them in the same part of the viewfinder, and pressing the shutter release at the place required, while the camera is still moving. To ensure that the camera is kept in motion, you will need to 'follow through', with the horses still in the same part of the viewfinder, a couple of seconds after exposure. (See also pages 86–87.)

Done properly – and it does take practice – the result should have a blurred, insignificant background

with the subject showing movement, but still staying quite sharp.

Note that a faster shutter speed must always be used for a subject moving *across* the frame than for a subject moving *towards* the camera. For instance, a car travelling from left to right in front of the camera, at about 50 kph (30 mph), might need a shutter speed of 1/500 sec. With the car heading towards the camera, a slower speed of 1/30 sec would probably do.

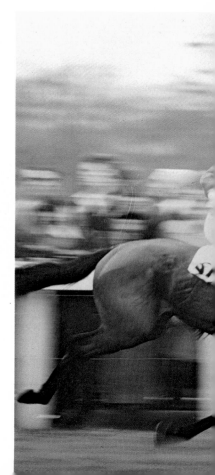

Left: The roller-blind shutter, found in most SLRs. The 'gap' makes the exposure. Below: The leaf shutter is made up of several metal blades, which open and close.

Panning. In this shot, the photographer selected a moderately slow shutter speed (around 1/60sec), followed the horses, made the exposure, and continued to 'follow through' after the shot. The result is a 'streaking' effect suggesting speed and excitement. Gerry Cranham.

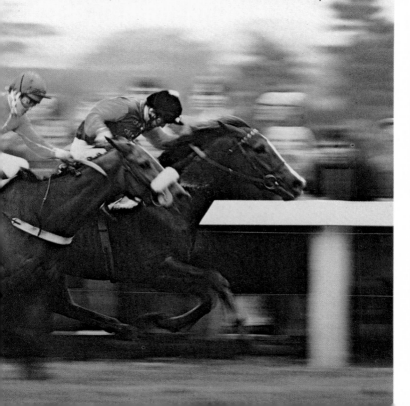

Exposure

Exposure is a combination of shutter speed and aperture, as these are the camera functions that control the amount of light reaching the film. On many cameras, calculating the right exposure is painless, because they either offer automatic exposure, or have built-in TTL metering which indicates exposure.

Automatic Cameras

Many 35mm compact cameras are automatic – the built-in light-sensitive cell takes an overall reading of the scene, and automatically sets the camera shutter speed and/or lens aperture for a correct exposure. Of course, not every lighting situation is straightforward. For example, if you are photographing a person on a brightly lit beach, the camera may expose for the bright sand and will thus underexpose the subject's face.

Some cameras have an *exposure memory lock*, which can be used to overcome this sort of problem. You first move close to the subject, take a reading from the face, and press the shutter release *slightly* to 'lock' the exposure. You then move back, frame and focus, and press the shutter release further to take the shot. As a result, the exposure should be correct for the subject's face. The surrounding sand will be slightly overexposed, but it is the subject that is important in this shot. A similar technique can also be used if the subject is back-lit, perhaps with the sun behind and the face in shadow. In this case, you would move in and take a reading from the face, 'lock' the exposure, step back and then shoot.

TTL Metering

Most cameras with TTL metering give very accurate exposure results. However, in situations where you consider that a little more, or less, exposure is needed, you can adjust the lens aperture or shutter speed accordingly.

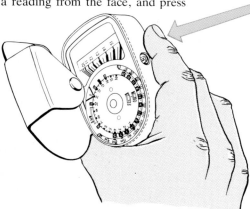

On the Weston light-meter (shown here), the reading can be 'locked', and the number shown on the needle scale is then selected on the meter's main dial. The required shutter speed//lens aperture can then be selected from scales on the meter for a correct exposure.

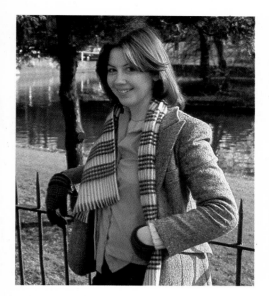

Above: These three shots, all taken on the same roll of colour-slide film, show how exposure can affect the final result. The large picture was exposed correctly according to the camera's light-metering system. The top right picture was underexposed and appears too dark. The bottom shot was overexposed and it appears light.

Exposure Latitude

All film has some degree of *latitude* – that is, the amount by which an exposure can be varied and still give an acceptable result. Latitude really depends on the type of film in use. Black-and-white film is quite 'forgiving' and can be over- or underexposed by a couple of *f*/stops without too much effect on the image. Colour negative film has reasonable latitude, although too much exposure variation can affect colour quality. Colour reversal film needs the most accurate exposure.

Exposing for Effect

There are certain situations where a so-called 'correct' exposure may not be required. For example, taking a black-and-white (or colour negative) shot of a dark, moody landscape, you may wish deliberately to underexpose in order to enhance the *low-key* effect, and create a darker picture. (With colour reversal film you would have to *overexpose* for a similar effect.)

Alternatively, you could give a child portrait more of a bright, *high-key* effect by deliberately overexposing black-and-white or colour negative film (underexposing colour reversal).

When using colour, particularly reversal film, a certain amount of colour variation can be brought about by deliberately under- or overexposing. You can experiment with exposure here to see the effect you most prefer.

Film

Black and White

Every black and white film has an emulsion coating made up of tiny granules of silver halides. These are compound salts of silver, which, when exposed to light, form grains of black metallic silver. Because light forms black silver, the image on the film is seen in a reversed, or negative, form – white appears as black, and vice versa. This *negative* can then be printed onto silver halide-coated paper to form a *positive* image – that is, a normal black-and-white print. Black-and-white films that are sensitive to *all* colours are called panchromatic films.

Speed Rating

Each type of film has a particular sensitivity to light, usually referred to as *film speed*, which is indicated in either ASA or DIN numbers on the film and the film carton. Film speeds can be divided into four broad categories – slow, medium, fast, and ultra-fast.

Slow (50 ASA or less). This type of film is relatively insensitive to light, and in poor lighting requires long exposures. However, the silver halide grains in the film are very tiny, affording extremely high image resolution and sharpness. For this reason, slower film is ideal for close-up work, copying and anything else where a high degree of detail is required. But results can be quite contrasty.

Medium (50 to 125 ASA). This is an all-purpose film, offering good image quality and exposure versatility. It can be used in a wide variety of situations, although in low light a wide lens aperture and/or slow shutter speed may have to be used. The high resolution of the image can stand considerable enlargement with little loss of quality – so it is a popular

Black and White Film Types

Film	ASA	Sizes Available
Agfapan 25 Prof'n'l	25	35mm, 35mm b/l, 120, 5 x 4 sheet
Agfapan 100 Prof'n'l	100	as above
Agfapan 400 Prof'n'l	400	as above
Agfaortho 25 Prof'n'l	25	as above
Agfa Dia Direct Reversal	32	35mm*
Efke-Adox KB14	20	35mm, 35mm b/l
KB17	40	as above
KB21	100	as above
R14	20	120
R17	40	120
R21	100	120
Ilford Pan F	50	35mm, 35mm b/l 120 '935' refill
FP4	125	as above
HP5	400	as above
Kodak Panatomic-X	32	35mm, 35mm b/l
Panatomic-X Prof'n'l	32	120
Plus-X Prof'n'l	125	35mm, 35mm b/l
Royal-X Pan	1250	120
Tri-X Pan	400	35mm, 35mm b/l, 120
Verichrome Pan	125	120, 620, 127, 110, 126

*Cost includes processing. b/l=bulk length.

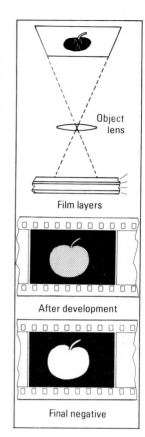

Object lens

Film layers

After development

Final negative

With black and white film, a positive subject appears as a negative image.

studio film. Medium-speed film is also less contrasty than slow film.

Fast (200 to 400 ASA). Fast film can be used in nearly all lighting conditions because of its extreme sensitivity to light. So it is useful in low light situations, or where it is necessary to use a fast shutter speed to freeze a moving subject, as in

sports photography. Because of its sensitivity, it is difficult to use in very bright conditions without over-exposing, and its relatively large grain size becomes apparent in enlargements beyond about 25×20cm (10×8in). But it is a low-contrast emulsion, so it is ideal for harsh lighting conditions.

Uprating Film

In order to increase the light sensitivity of a film, a process called *uprating* can be used. For instance, a 400 ASA film can be uprated to 800 ASA in very poor light, and later developed as an 800 ASA film. The images should be correctly exposed, although the uprating technique does cause a loss in definition because of the prolonged development time.

Special Films

There are other types of black and white films, which can be used for special purposes, or effect: *Line film* is a high-contrast film that produces only blacks and whites, with virtually no grey mid-tones. So it is useful for copying text, ink drawings, and so on. *Lith film* is very contrasty, producing an almost 'lithographic' result. It is usually developed in special lith developers. *Infra-red film* has a colour sensitivity that extends into the infra-red wavelengths. Used in conjunction with a special filter over the lens, the film reproduces green foliage as hazy white. It can also be used in the dark, with a special infra-red lamp or flash, for, say, photographing nocturnal animals. *Reversal film* is used for making black-and-white slides.

Taken on slow film, this picture has excellent definition and very fine grain in the print. Mervyn Rees.

Fast film is necessary for most types of stage lighting particularly when a fast shutter speed is essential; picture taken on 400 ASA film, uprated to 800 ASA. Pentax, 135mm lens, 1/250sec, f/3.5, Tri-X.

Film Format

As a rule, quality relates to the size of the film format. For example, a print from a 10×12.5cm (4×5in) sheet-film negative will be of better quality than one from the tiny 110 negative, because the degree of enlargement is less.

How Black-and-White Film Works

Most film emulsions contain a compound of silver with a halogen (either fluorine, chlorine, iodine, or bromine), coated onto a plastic base. Under the base is an anti-halation coating which helps to prevent reflection and multiple images forming on the film.

When light hits the silver particles on the film, an invisible, or latent, image is formed. Then, when the film is developed, the exposed halides turn black and the unexposed particles are later removed from the film surface, leaving the 'shadow' areas clear.

Light and dark areas on the negative correspond to different concentrates of silver halide on the film surface.

Film Formats

Type	Image Size	Description
110	13 x 17mm	Cartridge load
126	28 x 28mm	Cartridge load
127	42 x 42mm	Roll
120	6 x 4.5cm, 6 x 7cm, 6 x 9cm, 6 x 6cm, etc	Roll
35mm	24 x 36mm (18 x 24mm half-frame)	Cassette-loaded or bulk length
70mm	70mm wide	As 120, but without backing paper
Sheet film	4 x 5in (10.2 x 12.7cm)	Supplied in boxes (10 or 25)

Colour

White light is made up of several different wavelengths, as can be shown by passing white light through a prism (see page 15). The light is split into the familiar colours of the visible spectrum, from violet to red.

If three primary colours in the spectrum – red, blue, and green – are mixed, they produce other colours (see diagram). This important factor means that a colour film need have only three layers, sensitive to the primary colours, to record other colours. So colour film consists basically of three layers of emulsion, each reacting to one-third of the spectrum: the top emulsion is blue sensitive, the second blue/green sensitive, and the third red sensitive. (A yellow layer, below the first blue layer, prevents blue light from affecting the other layers, but this is lost at the developing stage.)

Film Types

As with black and white, colour films are also available in different ASA speeds. Recent developments in colour film manufacture have produced faster emulsions, making it easier for colour pictures to be taken in many conditions, even in low light. And, because these faster films are more sensitive to light, modern simple cameras which use them can have a faster fixed shutter speed of about 1/125 sec (to freeze movement and prevent camera shake) and a smaller lens aperture (for sharper pictures).

There are two types of colour film: *colour negative* film, from which a colour print can be made, and *colour transparency* film, which provides a colour positive image for viewing (a *colour slide*). Colour prints can be made from transparency film, but special reversal printing paper has to be used.

How Colour Negative Film Works

As the diagram shows, light hitting the negative film reaches certain areas of the film emulsion – blue light stops at the first, blue-sensitive, layer; green light stops at the green-sensitive layer; and red

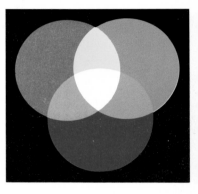

The three primary colours – red, green, and blue – can be combined to form other colours. A mixture of all three appears white.

goes through to the red-sensitive layer.

The light forms a black-silver image after development in all three layers. This is later removed by bleaching and fixing, leaving the dyes unaffected.

The finished negative shows an image in complementary colours – red is cyan, blue is yellow, green is magenta, and white is black. The negative also has an 'orange' mask to reduce colour contrast and improve colour reproduction.

When the negative is printed onto special dyed paper, the original colours are restored.

How Transparency Film Works

Transparency film is also called *reversal* film, because once the image is exposed it has to be reversed during processing to restore the colours as they originally were.

After the film is placed in a first developer, which forms black and white negatives in all three layers, the film is then washed and hardened before the image is 'reversed'. This is done by re-exposing the film to light, or by using a special fogging chemical.

The film is then colour-developed, bleached, fixed, and washed, and the finished transparency, with positive image and correct colours, is the result.

Colour Temperature

Each light source, daylight or artificial, has a particular *colour temperature*. The bluer it is, the higher the colour temperature; the yellower

Blue layer

Yellow filter

Green layer

Red layer

Reversal film Negative film

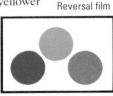
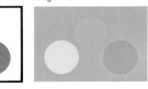

A colour film is basically made up of three coloured emulsion layers, and a yellow filter layer to absorb unwanted ultraviolet light.

it is, the lower the colour temperature. This temperature is measured in units of degrees on the Kelvin scale. A clear blue sky is about $15,000°K$, and a household bulb about $2,500°K$. Human eyes can adjust to any slight colour change – film cannot.

A colour film records a bright sky with a 'cold' blue cast, and a tungsten light with a 'warm' yellow cast. For this reason, there are two types of colour film – one balanced for use in daylight, the other for use in tungsten light (type B).

There are special lens filters that enable daylight film to be used in tungsten light, and tungsten film in daylight. The filters supply the necessary colour correction.

Colour Film Types (including b/w instant picture)

Film	ASA	Sizes Available
Colour Negative Film		
Agfacolor CNS	80	110, 126, 35mm 120, 127, 620
Agfacolor CNS 400	400	110, 35mm, 120
Fujicolor F-11	100	110, 126, 35mm, 120
Fujicolor F-11 400	400	110, 35mm, 120
Kodacolor II	100	110, 126, 35mm, 120, 620, 828, 127
Kodacolor 400	400	110, 35mm, 120
Sakuracolor II	100	110, 126, 35mm, 120
Sakuracolor 400	400	110, 35mm, 120
Colour Reversal Film		
Agfacolor CT18*	50	35mm, 120, 127
Agfacolor CT21*	100	35mm
Agfacolor ST110/126	64	110, 126
Agfachrome 50S	50	35mm, 120
Agfachrome 50L	50	35mm, 120
Fujichrome 100RD*	100	35mm
Kodak Ektachrome 64	64	35mm, 110, 120, 127
Ektachrome 160 (tungsten)	160	35mm, 126
Ektachrome 200	200	35mm
Ektachrome 200 Professional	200	120
Ektachrome 400	400	35mm, 120
Kodachrome 25*	25	35mm
Kodachrome 64*	64	35mm, 110, 126
Peruchrome C19*	64	35mm
Sakurachrome R100	100	35mm, 35mm bulk length

Instant Picture Films		
Kodak		
Kodak PR10	Colour print	10
Polaroid		
Type 665	B/W print and negative	8
Type 107C	B/W print	8
Type 87	B/W print	8
Type 88 P2	Colour print	8
Type 108 P2	Colour print	8
SX-70	Colour print	10

*Price includes processing.

Right: Each brand of colour film has its own particular characteristics. The shots here were all taken consecutively, using the same camera and lighting set-up. Although most of the films produce a fairly accurate result, there are differences between them if you examine the originals closely. Choose the film that may suit your needs and try a few out if necessary.

The print below has been made from the above colour negative. The negative shows complementary colours of the original scene – red appears as cyan, green as magenta, etc.

Kodachrome 25

Agfacolour CT18

Fujichrome 100 RD

Ektachrome 64

Ektachrome 400

Ektachrome 200

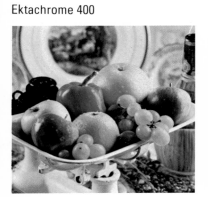

Using Light

Once you have become familiar with the camera controls, the real job of photography begins – and that means learning how to use light.

Light itself comes in many forms, from daylight to candlelight, offering the photographer the opportunity to produce different effects. Indeed, a whole range of styles, moods, and textures can be created for the camera simply by taking pictures under different lighting conditions.

A portrait taken in bright sunlight, for example, would have a completely different mood and impact from one taken in low lamplight. So there is always the chance, with any particular subject, to experiment with light and capture interesting effects.

A photographer's ability to use light can also help him to carve out a particular photographic style. Many of the great photographers have proclaimed to have very little knowledge of cameras or other technical equipment – but their ability to manipulate light has enabled them to create great photographs. And there is always something new to learn.

Many camera users are tempted to take their photographs in 'good' lighting – which is fine if capturing the image, rather than producing a creative effect, is what you want. But every photographer should attempt the odd shot in 'difficult' lighting. The result may be disastrous – but, you never know, your picture might be a winner!

Natural Light

Daylight is often the most pleasing light source for photography because it can give the most natural results. Of course, it can be unpredictable, depending on such factors as time of day and weather. But overcoming lighting problems is half the challenge of photography.

Natural light itself comes in many forms:

Bright sunlight. Many photographers take the majority of their pictures in bright sunlight, because sunlight can produce crisp, bright pictures. But because the sun is such a harsh light source, you must beware of deep shadows being cast on the subject. This can be very important when photographing people – harsh shadows on the subject's face will probably spoil a portrait shot. On the other hand, people facing directly into the sun tend to squint their eyes at the camera. It is much better to have the sun slightly behind, with the face in shadow and the hair rim-lit by the sun. But remember to take the light reading

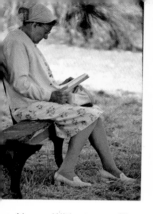

Above: With a tree to filter the sun's bright rays, the lighting is even and shadowless. Canon 1/60 sec, f/8, 200mm lens, Kodachrome.
Right: Window light gives a natural effect. Ricoh, 50mm lens, Ektachrome.

Left: This shot was deliberately taken against the sun, so that no shadows were cast on the face. Konica C35, 1/60 sec, f/11, Ektachrome.

from the facial shadow area, not the brighter background; otherwise the subject's features will be under-exposed. And when facing into the sun with the camera, make sure that light rays do not strike directly onto the lens; otherwise light 'flare' may spoil the picture. A lens hood is a good precaution.

Hazy sunlight. In hazy sunlight, when small clouds or haze filter out the direct rays from the sun, the problem of shadows is slightly eliminated. Yet conditions are still good enough for bright pictures. Little wonder that many photographers think this is ideal 'shooting' weather.

Dull light. Dull lighting conditions (on a cloudy day) will often produce very 'flat' results in pictures because of the lack of contrast in the light. Even so, you can turn this to advantage for producing dark, moody effects, particularly in landscapes and views. Obviously, when the light level is quite low, a long exposure, or fast film, may be needed to record the image. In such a situation you will need a tripod to support the camera.

Diffused light. Even in the brightest sunlight, it is possible to find shadowless lighting areas. For instance, hanging trees can filter out excessive sunlight and produce a

53

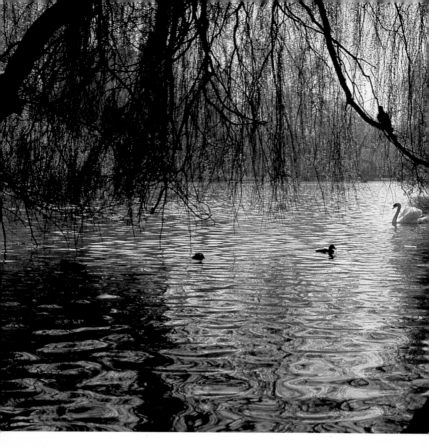

Light reflecting on water helps to catch the serenity of a parkland scene. Canon, 50mm lens, 1/125sec, f/8, Kodachrome.

softer, diffused light for views, say. Or you can make your own diffuser, using a white umbrella or semi-transparent card, to soften harsh lighting falling onto the subject's face in a portrait.

Available light indoors. Natural light, coming through a window, door, or even skylight, can be used to take pictures indoors. This type of light tends to be one-directional – in a window-light portrait, for instance, the light may fall on one side of the face only, leaving the other side in shadow. This can be effective, but, if more detail is required on the unlit side, a piece of white card can be held to reflect the incoming light onto the darker side. Available light can also be used in photographing interiors, for a natural and 'liveable' look. Again depending on how much available light there is, you may have to use a tripod or fast film.

example, might transform a normal looking landscape into an interesting, moody one that is worth photographing.

The weather can throw up a variety of picture possibilities. On a very hot day, a heat haze might produce a misty effect that can be captured on film. Or, in a rainstorm, interesting reflections can be seen in wet roads – this is particularly effective in a lamplit street at night. Other weather phenomena that can produce good pictures include a rainbow in the sky, a wind-swept street, or the sun breaking through the cloud formation. As a rule, the more dramatic the weather, the better are the pictures. So don't be afraid to go out in the rain if you think it will produce a good shot!

Below: Lighting changes dramatically with the weather. In winter, low sunlight can produce interesting effects, especially on snow. Leica, 50mm lens, 1/160sec, f/5.6, Kodachrome.

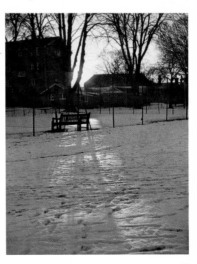

Effect of Weather

Natural light is governed by one unpredictable force – the weather. In photography, weather not only dictates the amount of light we have to play with, but also its mood and texture.

The unpredictability of weather is such that the photographer must keep a constant eye open for any change in lighting conditions that might affect exposure. Weather changes can also produce interesting picture possibilities that were not foreseen – a sudden cloud shift, for

55

Time of day

When you first spot a promising picture, it's tempting to take the shot there and then. This might be fine in many cases and there may be little need to try to improve on a shot later. But some pictures deserve extra thought. Light changes considerably during the course of a day. Try shooting a series of pictures at different times and see the variety of effects you can achieve. Experience will tell you that some shots are better in certain lights.

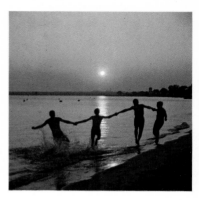

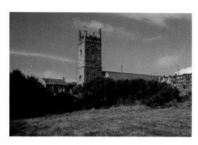

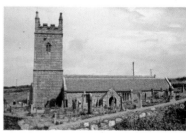

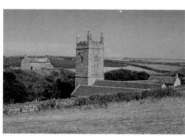

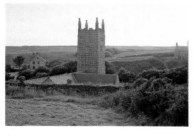

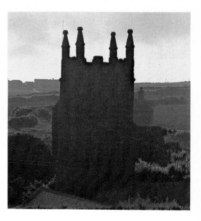

These five pictures of the same church were taken at various intervals during one day. Note how not only the direction of the light changes, but also the coloration.

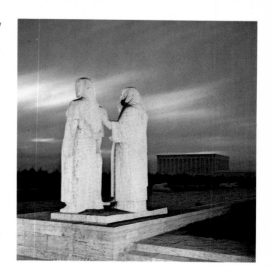

Left: Not all pictures should be taken in the full brightness of day. In this shot of holidaymakers on a beach, the photographer waited until sunset. The result is warm and pleasant and, with the people silhouetted against the setting sun, the photographer has succeeded in conveying the beauty and romance of the location. 1/250sec, f/16, Ektachrome.
Right: An early rise allowed the photographer to catch a moody sky at dawn. Flash was added to give detail to the statues.

Artificial Light

Artificial light also comes in many forms and can be described as any light that is not natural. But usually the whole idea of using artificial light is to make it appear as natural as possible in the photograph. In other words, artificial lighting should not always look artificial.

Artificial light does have many advantages for the photographer. Unlike natural light, which can be very unpredictable, artificial light is a constant light source that can be used day or night. The light output is also regular, which helps to eliminate any exposure problems.

But, perhaps most importantly, most artificial light sources can be moved around, making it easy for the photographer to change the direction, strength, and even the whole mood of the lighting. For example, you can shine the light directly onto the subject, or bounce it off a wall (or a piece of white card)

to simulate natural daylight. Or you can place different coloured gelatine filters in front of the light source to change the coloration in the picture.

Of course, most artificial light sources designed for photography have to be bought in addition to the photographer's camera equipment – unlike natural light which is 'free'. However, it need not be an expensive item – a couple of studio lamps, or a small flashgun, may be all the average enthusiast needs initially. More expensive indoor lighting may be purchased later if required.

Lamps

Studio lamps come in various shapes and sizes. *Floodlights* usually have a 125-500-watt lamp and a 'dish' reflector to spread the light evenly. Most are made of lightweight aluminium materials, so that they are easy to carry and move around the studio. *Spotlights* are designed to give a directional 'spot' of light, the spread of which can usually be ad-

justed by moving the internal reflector. They are normally used for highlighting particular parts of the subject – perhaps backlighting the hair – or lighting the background.

Lamplight is easily controllable in that you can move the lamps around until you achieve the desired lighting effect. But quite a lot of heat may be generated from the bulbs, so you might have to turn them off now and again during a session, particularly in a small studio area, and ventilation of some kind is advisable. Some of the larger bulbs have short lives and replacements are expensive, so for economic reasons they must be handled with care.

Film note. When using lamps for colour slide photography, tungsten-balanced film should be used for correct colour rendition. (Daylight film may be used only with special correction filters on the camera lens.)

Household Light

Special photographic lamps are not always necessary for taking pictures indoors – ordinary household lighting may be used. Most house lighting is too low for photography, so a fast film, or very long exposures, may be needed. Ceiling lamps tend to throw awkward shadows, and it is often

Above: One of the problems when firing flash directly at someone is 'red-eye' – the flash bounces directly off the retina and makes the eyes appear red. This can be remedied by asking your subject to look slightly sideways into the camera (as pictured above right).

Right: Candlelight gives a warm and natural effect in a picture. In some cases a tripod may be needed if the low light level requires a long exposure.

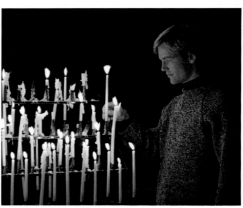

better to use a standard lamp that can be moved to suit the subject. Again, tungsten film should be used for colour work.

Candlelight
Very effective pictures can be created using candlelight. The light from the flame gives a warm, pleasing glow to the subject. But the light level is so low that a long exposure or very fast film (400 ASA, possibly uprated) is required. For this kind of lighting, experiment with exposures for best effect.

Flash
See *Flash* chapter, pages 62-63.

Mixed-light shot of Bourges Cathedral interior. Daylight has lit the stained glass windows, with flash lighting the interior.

Mixing Light

There are many situations where both natural and artificial light can be mixed together in one photograph. For example, when taking a portrait indoors, you may use window light as the main light source, with lamplight 'filling in' some of the darker shadow areas. Or outdoors, you may use the sun as the main light source, with a hint of flash light to brighten up any shadow areas, giving the shot more sparkle.

Mixing light is one of the areas where the photographer can experiment the most – trying different combinations and exposure variations for particular effects. When using colour, the choice between daylight or tungsten film will usually depend on which is the stronger of the mixed light sources.

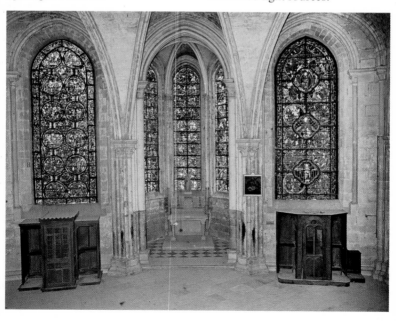

Night Photography

The development of fast film has made it much easier to take photographs at night, without the need for long exposures. In a brightly lit street, for example, it should be possible to use a reasonably fast shutter speed so that the camera can be hand-held and not balanced on a tripod.

The most successful night shots are usually taken at dusk, when there is a delicate balance of light from buildings and low 'available' light adding some colour to the sky. This is often much more interesting than having just a black sky. The balance can be changed by altering the exposure – with colour reversal film, overexposing will lighten the sky, underexposing will darken it – and it is a good plan to experiment.

When shooting colour, you must bear in mind that ordinary street lighting does not give correct colour rendition, because it cannot produce a full range of light wavelengths. Results will either be very blue, or very orange, depending on the light source. A little daylight in the sky can help overcome the problem.

Fireworks shooting into the sky are best captured by putting the camera on a tripod and using an exposure of a few seconds, so that the colourful path of the fireworks is fully recorded.

During very long exposures, the film may undergo what is known as *reciprocity failure*, because it is being pushed beyond its exposure capabilities. In such cases an increase in exposure is required over and above the assessed amount, although experimenting with different exposures is usually best anyway.

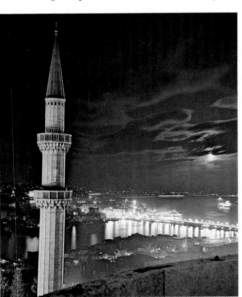

Left: A long exposure was used for this night view of a Turkish minaret. Ektachrome, 1½ min, f/8. Sonia Halliday Photographs.

Night Exposure Guide (400 ASA)

Subject	Sec	f
Bonfire	⅟₁₅	4
Fireworks	⅛	5.6
Interiors*	¼	8
Shop windows*	⅟₃₀	4
	⅟₁₅	5.6
Stage*	⅛	8
Streets*	¼	4
Average home lighting	½	5.6
	1	8
Floodlit buildings	1	4
	2	5.6
	4	8
andscape at full moon	1m	4
	2m	5.6
	4m	8

*Well lit.

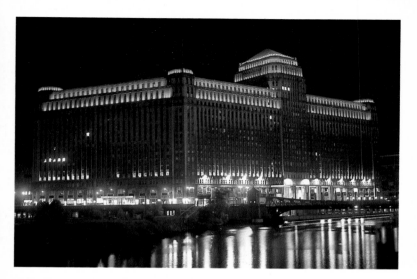

Above: Extra interest is added to this night shot by the light reflections on the river.

Left: Fireworks can produce brightly coloured night pictures. Here the fast-spinning firework gave out enough light to make a hand-held exposure possible – no tripod was needed.

Right: When flash is used to capture night action, the subject can be dramatically highlighted. Sometimes an infra-red beam is used to trigger the camera and flash.

Flash

Unlike most other types of lighting, flash is designed to give a spontaneous 'burst' of light. For that reason, the photographer has to experiment with flash, assessing exposure and finding out the best way to use it.

Flash units are connected to the camera by means of either the hot shoe or a small synchronization socket. Once connected, the unit will go off when the camera shutter is fired. Many cameras have two 'sync' sockets – an 'M' socket for bulb flash units and an 'X' socket for electronic flash.

Cameras with horizontally running focal-plane shutters should be set to the 1/60sec shutter speed, or slower (otherwise the flash will not synchronize correctly); vertically operating shutters, 1/125sec (or slower).

With flash, exposure is controlled by setting the lens aperture. Every flash unit features a small calculator dial, on which you set the ASA film speed. The correct lens aperture to use is indicated opposite the particular subject distance.

Another way of calculating exposure is to use the *guide number* recommended by the flash manufacturer for the particular ASA film speed in use. The guide number (there is one for metres and one for feet) is divided by the flash-to-subject distance to find the lens aperture required. For example, say the suggested guide number of a particular unit is 32 (for metres) and your subject is 4m away. The calculation would then be: $32 \div 4 = 8$ – that is, $f/8$ is the correct exposure.

There are two types of 'on-camera' flash – *auto/manual* and *fully manual*. The latter gives a constant burst of light, with exposure controlled either by the lens aperture or the distance from the subject. With an auto/manual unit, set to *auto*, the light output is controlled by special circuitry inside the unit. A tiny sensor on the flash picks up reflected light from the subject and 'cuts off' the unit's output – so a correct exposure can be made with-

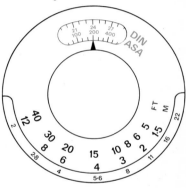

Above: The type of calculator dial found on most flashguns. The ASA film speed is set, and the correct aperture to use is shown opposite the subject distance, e.g. f/5.6 at 4m.

out moving the unit, or adjusting the lens aperture.

Other types of flash include heavy-duty professional units (featuring separate power packs) and mains-operated studio units. With the latter, a special *flash meter* can be used to measure exposure very accurately.

Film note: Electronic flash (and bulb flash) units are balanced for use with daylight colour film.

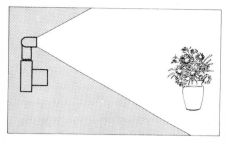

Here the flashgun, mounted on top of the camera, is aimed directly at the flowers. The resulting picture shows little texture and harsh shadows.

For the second shot, the flash was tilted upwards so that the light bounced off the ceiling down onto the table. The effect is softer and more natural.

Finally, the flash was tilted to one side so that the light bounced off a wall. The result simulates daylight coming in from a window.

Composing the Picture

Composing a photograph is just as important as focusing and exposing it correctly. Most photographers have a few badly composed pictures in their collections – examples showing the subject lost in the background scenery, or with head or feet cut off in the picture, or even a background tree seemingly growing out of the subject's head.

Initially, these are all easy mistakes to make, and quite often the photographer is too concerned with capturing the picture, or adjusting the camera controls, to think about composing the shot.

All pictures are composed, or framed, in the camera viewfinder. Most simple cameras have a bright-line frame, usually marked in yellow, anything outside of which will not be included in the final picture. On an SLR, nearly everything you see in the viewfinder will appear on the film.

In many situations, you might have time to think about a particular viewpoint. It is worth taking the

The foreground figures to the left lead the viewer's eye naturally into the general view of the river.

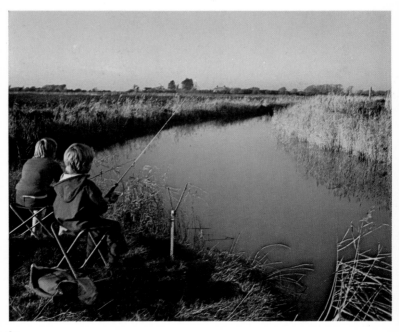

trouble to look carefully at the subject, the background, and any other contributing factors to determine the best angle and distance to shoot from.

When photographing a building, for instance, you might decide to step back and take in the whole structure, or move in closer to pick out certain details. If you take a variety of shots from different angles, you can later select the most pleasing of the pictures. By experimenting, you learn from any mistakes you make, and avoid them later. If you have a choice of lenses, you can change the perspective of the same view by switching from, say, a wide-angle lens to a telephoto lens – without moving the camera.

Most photographers tend to hold the camera in the normal *view* position. But many subjects lend themselves better to an *upright* shape. If, for example, you wish to take a full-length portrait, with the camera in the view position, it would be necessary to move back to avoid cutting off part of the subject's legs. By turning the camera upright, all of the figure can be included without the need to move farther back. And any unnecessary background can be kept out of the shot. Try upright or view shots of a few subjects, and see which are the most effective.

Background and Foreground

The use of background and/or foreground in composing is very important. Background detail can enhance the main subject in the photograph – but it can also spoil the effect of the picture. The background should look as natural as possible and should not be too bright or distracting. A red background, for example,

Foreground detail is important in this composition. The cottage in the background is the main point of interest and the line of boats leads the eyes towards it. Konica 38mm lens, 1/125sec, f/16, Ektachrome.

may distract from shots of people.

Alternatively, using a long telephoto lens and/or a wide lens aperture will help to throw the background out of focus. *Selective focusing,* where the lens is focused on a close subject, will also have the same effect.

Foreground detail can also be used effectively in a picture to lead the viewer's eye naturally to the main subject, such as a path winding its way up towards a house. Out-of-focus foreground detail can also give an interesting 'rim' effect to the shot, such as flowers close to the camera lens in a landscape picture. And you might use overhanging leaves (in or out of focus) to 'frame' a landscape.

Using Filters

Black and White

Filters are used in controlling the tonal quality of black and white photographs and for producing special effects. On a black and white panchromatic film, colours reproduce as various grey tones. These tones can be changed and manipulated by using different-coloured filters over the camera lens.

Coloured Filters

When a coloured filter is used with a black and white film, it will lighten the same colour in the picture. For example, a green filter over the lens will *lighten* the tone of green foliage. But the complementary colours, red and blue, will *darken* it.

The uses of various coloured filters are given in the table opposite. Each of these coloured filters is available in different densities – a ×4 yellow filter will give a more pronounced effect than a ×1 filter. For most purposes, a medium-strength filter, about ×2, is adequate. Remember, though, that coloured filters can reduce the amount of light reaching the film, so extra exposure (half a stop) may be needed. However, the TTL metering in most SLR cameras should automatically compensate for any extra exposure required.

Colourless Filters

Apart from the various coloured filters, there are other types available for special applications. These filters can also be used for colour work.

Ultraviolet filter. Although our eyes do not respond to ultraviolet light, black and white film does, and it can produce a pale, misty effect in a landscape or mountain shot. A UV filter will absorb some of the UV light and eliminate this problem. It may also be used in a similar way for colour. Most photographers keep a UV filter on the lens permanently to protect it from dust and dirt.

Polarizing filters are used to minimize unwanted reflections in a photograph. For example, when photographing someone through a window, you can eliminate the reflections by rotating the front of the filter until they disappear. For colour

An example of how a yellow filter can darken sky detail in black and white work.

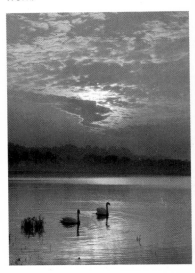

Left: Filters screw into a threaded mount on the front of the camera.
Below: As a rule, a filter of one colour lightens the same colour in the original scene, and darkens other colours. In the four shots below, the filters used were, from the top: no filter, green, red, and blue.

work, polarizing filters can increase contrast and improve colour saturation – that is, increase the strength of the colours in the picture.

Neutral density filters reduce the amount of light reaching the film without affecting tonal quality. In bright light conditions, it may be impossible to use a wide aperture (to reduce depth-of-field for a specific purpose) without overexposing the film. With an ND filter, the light level can be reduced, allowing a wider aperture to be selected.

Black and White Filters

Yellow: Increases contrast in a picture, particularly where the lighting is slightly 'flat'. Will also darken a blue sky in a landscape, and bring out any cloud detail.

Green: Also useful in landscape work – to lighten green fields and foliage.

Orange: Has a slightly stronger effect than yellow in darkening the sky. Also gives extra contrast.

Red: Again useful for landscapes, darkening the sky quite dramatically. Very high contrast.

Blue: Absorbs the colour of a blue sky, making it appear white. It also decreases contrast, creating a flat, often misty, effect.

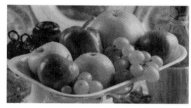

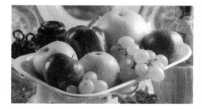

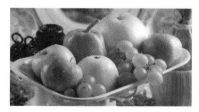

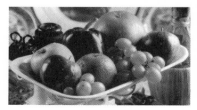

Left: A problem with photographing through windows is reflection. One solution is to use a polarizing filter, which eliminates this reflective glare. However, in this case, an alternative would have been to wind the window down!

Filter Fittings

Most filters are just circular pieces of glass fitted into a holder, which screws onto the front of the camera lens. The size of lenses varies, though, and this can be a problem if you own several lenses with different filter fittings. It might involve buying the same filter in various sizes.

But there are now filters on the market that consist of a special holder, which takes large square glass filters. The holder is fitted to the lens by an adaptor ring, which can be changed according to the particular filter size. So you have only to buy the suitable adaptor rings, and one filter will fit all your lenses.

Colour

Colour-Correction Filters

The human eye can readily adapt to different light sources. If, say, you view a white object in daylight, and then under artificial light, it will appear white in both cases. Colour films do not have this kind of flexibility. Each type of colour film is designed to respond accurately to a specific light source. For example, daylight-type film will produce accurate results in daylight, but in artificial light the results will appear too red, or 'warm'. And tungsten-type film responds accurately to artificial light, but in daylight results appear too blue, or 'cold'.

So, why should you need to use a

Above: Sometimes a correction filter is needed to reproduce colours more accurately. Both shots here were taken in early evening light – the left-hand picture, taken without a filter, is too blue. An orange 85B gives the second shot a more natural colour rendering.

daylight film indoors anyway? Well, you may be shooting a series of shots that include both indoor and outdoor locations. Using daylight film for outside, you would then have to change to a tungsten film for correct colour rendition for indoor artificial lighting. In such a situation, a colour-correction filter, fitted over the lens, may be used to restore the correct colour balance – without the need to switch to another film.

There are various types of colour-correction filters available, and the choice will depend on the colour temperature (measured in degrees Kelvin) of the light source and, of course, the type of the film in use (see the table on the left).

Light-balancing Filters

Even when using a film under correct lighting conditions, it is sometimes desirable to make the colours 'warmer' or 'cooler'. For example, an *82B* filter – used to balance Type B tungsten film (3200°K) in household lighting (2900°K) – may, with its slightly cooling effect, also be used to cut down the reddish tones in late evening or early morning light. Likewise, filters that decrease the colour temperature and produce 'warmer' redder tones, such as the *81A* – used to balance tungsten Type B film (3200°K) under photoflood lamps (3400°K) – may be used also to warm-up a landscape taken in cold, wintry lighting.

Fluorescent lighting also causes problems in colour photography, because it can produce a green cast with daylight film. You can eliminate this by using an *FL-Day* filter with daylight fluorescent lighting and an *FL-W* with white-type tubes.

69

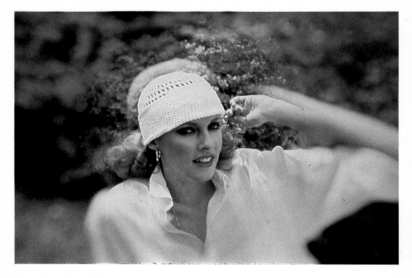

Special-effects Filters

In addition to filters used to correct tone (in black and white) and colour balance (in colour), there are also many special-effects filters available. These filters are designed to give the photographer extra creative scope without the need for expensive specialist equipment.

Most are designed for colour work although a few are also suitable for black and white, including the star-burst, soft-focus, and fog filters. Some of the most popular special-effects filters are described, together with their uses, in the table on the opposite page.

Combining Filters

It can be very interesting to combine certain types of filters for special effects. For instance, when shooting a landscape into the sun, you could use a graduated filter to darken the sky, and a star-burst filter to give the sun a star-shape.

A centre-spot filter has a clear central area, with an outer irregular area that gives a soft focus effect around the subject's head.

There are countless other possibilities – many filter manufacturers produce brochures which may suggest other interesting filter combinations.

Buying Filters

Most simple filters are reasonably inexpensive, but special-effects filters are more pricey. There are hundreds of different filters on the market, but you will not need all of them. Many photographers make do with a few coloured filters, for black and white work, a couple of correction filters, for colour, and perhaps one or two special-effects filters.

Choose the filters you think you really need – buying too many, and then not making sufficient use of them, is a waste of money.

Special-Effects Filters

Starburst filter: Used to transform a strong single light source (a lamp, say) into a star-shape. The 'points' on the star are created by thinly etched lines on the surface of the filter. Number of 'points' varies – a 'Star Six' filter, for instance, will produce six-pointed star shapes.

Soft-focus filter: Slightly cloudy filter used to produce a soft-focus effect – ideal for portraits. It may be cloudy over the whole surface *(diffusion filter)*, or just around the edge, leaving a clear central area *(soft-spot filter)*. A similar soft effect may also be produced by coating a UV filter with Vaseline, or by placing a stocking over the lens.

Fog filter: For creating a misty effect. Fog filters often come in sets of three, so that the effect can be varied.

Colour Work

Graduated filter: A half-coloured filter, with the colour gradually running into the clear half of the filter. It affects only one half of the image. For example, the sky in a landscape may be darkened with the coloured half, while the lower ground detail remains clear. The filter can be rotated, depending on which part of the image area requires coloration.

Colour spot filter: Coloured filter with a clear central area. The subject can be framed in the central part, while the surrounding area takes on the colour of the filter. Ideal for romantic or atmospheric pictures.

Dual colour filter: Filter with a different colour in each half, producing a dual-colour effect.

Tricolour filter: Filter divided into three different colours, in parallel, or in triangles. Gives imaginative three-tone effect.

Diffraction filter: Special etched grid patterns on the filter break up white light into multiple colours. Ideal for night scenes, where ordinary street lighting can be made to look exciting and dramatic.

'Pop' filters: Available in a set of three – red, green, and blue. Used individually, they create a single colour cast for effect. Combined, they can produce interesting three-colour effects.

Below: A dual-colour (red and blue) filter gives extra impact to this landscape.

Below right: Multi-image filters are often used in advertising work for special effects.

The Subject

The photographer should never be short of subjects. People, places, events, animals, flowers, objects – all offer picture possibilities. Some subjects are there for the 'taking', and all the photographer has to do is point the camera and shoot. Other subjects, however, may require preparation and patience.

The greatest asset that any photographer can have is the ability to 'see' a picture possibility – the actual mechanical job of taking the picture can be secondary. It may often be necessary to search for the right subjects to photograph and, even then, you may need a little imagination to create an interesting image.

The photographer should also be prepared for the unexpected – so always take a camera out with you. Otherwise you may miss a vital shot and end up talking about the one that got away!

Special Equipment
Some subjects require specialized equipment, and the table below lists suggestions for the lenses, filters, and other accessories suitable for various groups of subjects. Some items are not needed initially, but may be added later as you progress. It pays to keep up to date with any innovations in your particular branch of photography by reading the specialized magazines.

Equipment Suggestions According to Subject

Subjects	Lenses	Filters	Other Accessories
Portraits Children Glamour	Telephoto: 80mm or 135mm Zoom: 24-48mm or 80-200mm	Skylight 1A Colour conversion (80A or 85B) Simple effects (soft-focus, etc)	Tripod Cable release Flashgun or other indoor lighting
Nature Close-ups Still life	Close-up 'macro' lens *or* telephoto *or* zoom lens with close focusing	Skylight 1A Polarizing	Tripod Cable release Close-up accessories (screw-on lenses, extension tubes, bellows, etc) Flashgun
Landscapes Travel Holidays Events Buildings	Wide-angle: 28mm Telephoto (135mm or longer) *or* zoom (80-200mm)	Skylight 1A Polarizing Coloured (red, green, yellow, etc) Effects filters (eg Chromofilters) where required	Tripod (or monopod) Cable release Lens hood
Sport Animals	Telephoto (200mm or longer) *or* long zoom (90-300mm)	Skylight 1A Polarizing Coloured (red, green, yellow, etc) Effects filters where required	Shoulder or handgrip (with built-in cable release) Autowinder *or* motor-drive

Still Life

Tackling still life is an excellent way of learning about photography. Because you are dealing with an inanimate subject, you can take time over the setting up of equipment and lighting, and the preparation and composition of your picture. Many of the techniques learnt from still-life work can be applied to other subjects.

Photography of still life can include virtually anything that doesn't move – some old wine bottles on a shelf, a bowl of fruit, an ornament – anything that catches your eye.

Natural daylight is often the most pleasing light source for still-life work, because it gives a natural effect. It works particularly well for subjects captured in their natural environment, such as fruit and flowers. In situations where the light may be uneven, and it is difficult to move the subject, try using a piece of white card to reflect the light onto unlit areas to give a more balanced effect.

When using lamps, you can light the still-life subject from various angles until you create the desired effect. By 'bouncing' the light off a white surface, it is possible to produce a softer lighting effect and perhaps even simulate daylight. With a subject such as bottles, lighting the background (rather than the subject) will show off their subtle shapes and textures.

With a little application, an ordinary still-life subject can be made interesting – and here the photographer can experiment. Apart from the various lighting techniques, you might try using coloured light in some parts of the picture for extra

The simplest of subjects can make an interesting still-life picture.

effect, or even special effects filters, such as a starburst or soft-focus (see page 71).

And because still life is as much concerned with composition as anything else, 'blending' different subjects together in the same picture can produce pleasing results. And so will a subtle blending of colours. Too much of one colour can be boring in a picture, and even in black and white it may reproduce as a single tone of monotonous grey.

For most still-life work, you will need only the simplest equipment. You may need a tripod, particularly when using indoor natural light, to steady the camera and enable you to use a slow shutter speed and small aperture (for maximum sharpness). A screw-on close-up lens or set of extension tubes may be necessary for close-up work, although most standard camera lenses will focus to about 0.5m (1.5ft).

Capturing Character

A good portrait should reveal something of the person's character – a cheeky grin, a fleeting glance, a pensive frown, or other expressions, can say something about the individual's personality.

By chatting to the subject, or somehow finding out a little about them, you can build an image in your own mind of how the portrait might be tackled. You will normally be concerned with such considerations as location, the mood of lighting, and the position of the subject.

A person's character is usually most evident in the face, and it is often necessary to move in close to emphasize the facial features, making any background insignificant. But in some cases the sitter's style of dress or general appearance may reveal certain characteristics, so a full-length shot may be more appropriate.

Interesting expressions or faces may be encountered almost anywhere. In a park, or a busy street, you are bound to come across characters with picture potential. One of the best ways to capture a natural and unselfconscious expression is with a long telephoto lens. Some people may even be glad to pose for the camera, though others may be suspicious and difficult to persuade.

Trying different character shots of the same person can be a useful insight into portrait photography. The best choice is someone with an expressive face – possibly an actor or actress from a local dramatic society. Apart from different facial expressions, special make-up or theatrical costumes and props can make the selection of pictures varied and interesting.

Above: Characters like this are a photographer's dream. Most people don't mind being photographed – but ask first.
Left: The worn face of this newspaper seller has made a fascinating character study. The cigarette in his mouth adds further interest.
Right: This picture, by Patrick Lichfield, of film star Britt Ekland shows the photographer's own soft, grainy style.

Evolving your own Style

Photographs taken by some of the great portrait photographers can often be identified, not simply from the subject matter, but by the photographer's individual style.

The word 'style' immediately suggests great photographic expertise – that may well be true in some cases, but even some of the 'masters' profess to have little technical knowledge. More often than not, it is the 'personal' approach to portraiture that dictates a particular photographer's style – and that is something that even the beginner can start to develop.

There are a great many factors governing the style of a portrait – choice of subject, location, choice and use of equipment, lighting mood, use of colour, printing technique, and so on. By experimenting with some, or all, of these elements, you will be able to see from the results the most pleasing effects and develop an approach from there.

There are plenty of useful accessories available for portraiture, such as special filters and soft-focus attachments, which can be used for producing certain effects. The results they can create are worth looking at, and you might find one or two that help you to develop your style. By keeping an open mind initially, and looking at many different examples of portraiture, you might find that a particular style appeals to you and experiment with it yourself.

People Indoors

Portraits can be taken indoors with a variety of light sources. The style of the portrait will probably determine the time of day for taking the pictures and the type of lighting.

Many photographers favour daylight when shooting indoors, Natural light produces a soft and pleasing effect in portraiture, although if it is coming from one direction, say through one window, the subject should be placed in that area.

Despite this restriction, working with daylight enables you to take portraits freely without lamps or other lighting equipment. But you might need some additional lighting to fill out any shadow areas. Pieces of white card can be used for reflecting extra light to certain parts of the subject's face. If the light level is low, you will need a tripod so that you can use slow shutter speeds, or you can use a fast film.

Artificial light can also be used successfully for portraits. With ordinary household lighting, ceiling lamps tend to give an overall 'flat' effect, so a standard lamp is often better, but watch out for harsh shadows that might be thrown onto the subject's face.

Special photographic lamps, or flash units, are often the most successful artificial lighting sources for portraits. They are quite bright and can be moved around to give more variety. A simple set-up might include one main lamp and a smaller second lamp, for filling in shadows or for backlighting (see *Studio* chapter, page 103).

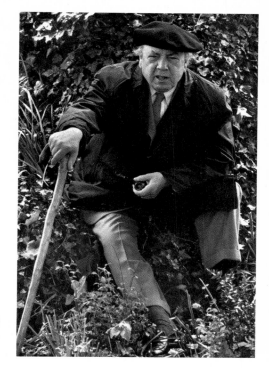

Right: This portrait of author J. B. Priestley by Snowdon is a fine outdoor character study. The photographer has chosen a viewpoint that completely eliminates any background distraction. The pose is relaxed, yet distinctive, and the subject appears to enjoy the outdoor life.

Opposite page: This shot of a couple in a café is obviously a set-up picture. Both are seemingly unaware of the camera, and the picture comes over as slightly humorous.

People Outdoors

Outdoor portraits are usually easier to tackle than indoor ones. To begin with, there is more light (doing away with the need for lamps or other artificial light sources) as well as more room than in a 'studio' situation. And because photographer and sitter are not in a restricting indoor set-up, the atmosphere tends to be more relaxed and informal.

Lighting outdoors is obviously governed by the weather and the season. Depending on the sort of portrait you are taking, you have to decide whether conditions will be suitable for the session. A bright sunny day might be right for photo-graphing a pretty girl, but wrong for lighting the pensive features of an old man.

It is not always possible to pick and choose the right time to photo-graph someone; you might come across a character who just has to be captured 'there and then'. In such a case, make the best of the lighting conditions and take the photograph – you might not get a second chance!

Although most indoor portraits are posed, it is quite easy to catch unposed pictures of people out-doors. By photographing from a distance, perhaps using a long tele-photo lens to bring the subject 'closer', you can get some intriguing shots.

Pets

Pets can be fascinating and often amusing subjects. You can take them outdoors or indoors, depending largely on whether you want action shots or 'posed' pictures.

You need plenty of light to photograph animals in action outdoors. This is because a fast shutter speed has to be used to stop the animal's movement, as well as a small lens aperture to increase the depth of field and produce the sharpest results, particularly when taking close-ups.

Pets at best are slightly unpredictable, and they can often be downright awkward when it comes to posing them for the camera. So it is a good plan always to be ready to take a shot as soon as the pet moves into position.

Outdoors

Gardens are highly suitable locations for pet pictures, especially if familiar ground to the animal. It is less likely to be nervously running around. And

With some animals the addition of the human element can make the picture. Most animals certainly won't run away when being fed!

garden fencing will help to keep the animal from straying off.

Some animals may be relaxed enough to select a piece of lawn and just sit happily while you snap away, but others may need a bit of coaxing. It is often helpful to have someone else who can talk to or play with the pet while you concentrate on taking the pictures. Most cats, for instance, will respond to a ball of wool dangled in front of them, and after a while they will be oblivious to you and your camera. Kneeling or lying down, you can take pictures from near ground level, and they will appear much more natural than if you were towering above the animal.

Most animals can be bribed or 'baited' into posing for you with food. Coat a small ball with a little fish paste, for example, and a cat will play happily with it, licking and rolling it about. Or you could put the bait onto a branch and catch the animal as it gracefully climbs the tree. By focusing on the spot where you think the animal will appear, and also working out exposure, you

can save time and catch the shot quickly. The animal probably won't wait around very long after the food has gone!

Indoors

To photograph pets indoors, you need plenty of light – either flash or special photographic lamps. But most pets tend to be even more restless than children, so lamps are often out of the question, quickly making it too hot and uncomfortable for the animal.

Flash is usually best, particularly when used 'on-camera'. In this way, you can follow the animal around. Alternatively, you could use a special flash set-up, with perhaps a couple of units to provide a strong overall light. The sharp directional light from the flashgun is also very good for showing up an animal's wide eyes or soft fur.

Flash is also very quick – some animals may be still only a second or so, so flash is ideal for capturing these moments. But take care, because some pets might react unfavourably to sudden bursts of light. Use flash sparingly if the animal seems perturbed. Some pets even dislike the whine of a flashgun as it recharges.

Equipment

A camera with an ordinary standard lens should be sufficient for most pet shots, although a short telephoto lens will help you to get in close in some situations. A tripod is almost out of the question, because animals move around so much, and anyway you will use a fast shutter speed for most animal shots. A cable release is useful to prevent the anxious photographer from pressing the shutter release button too hard when chasing a particular shot and shaking the camera.

Events

Events of various kinds provide plenty of scope for the photographer. Whatever the event – weddings or parties, fairs or carnivals – there are always people in animated action, often oblivious to the camera.

When taking occasions such as weddings, try to get some unposed pictures if possible, in addition to the formal ones.

Informal shots of bride and groom being showered with confetti, or kissing one another, complement the posed pictures, too many of which become boring. Watch for the brief moment after each 'official' shot is taken, when the couple may relax and look more natural.

Keep an eye on the children, as they often provide the best picture opportunities – the bridesmaid handing flowers to the groom instead of the bride, or the page boy tripping over the bride's train. In other words, look for the 'fun' of the occasion or for the unexpected.

A long telephoto lens is most useful for snatching surprise shots from a distance, and you might need a wide-angle lens for large group pictures. You will need a flashgun for the ceremony (ask permission first) and at the reception.

Organized events such as fêtes and carnivals are always lots of fun to photograph. At fêtes, for example, where people take part in games, they often let their hair down – so look out for the amusing moments. Adults acting like children often provide good pictures.

And at carnivals, the colourful clothes and the action are a photographer's dream. But use a telephoto lens to get in close for individual shots. These are much more interesting than interminable crowd scenes. The floats may also make very decorative and colourful backdrops to the characters on them, and watch out for street characters who walk alongside.

Fairgrounds throw up a host of potential portraits in the stall

Opposite page: This view of an opera, performed at night in an outdoor theatre, is the perfect event to photograph, because there is plenty of colour and life. In this situation, it is pointless using flash, because you would be too far away from the stage. Use a fast film (400 ASA) and take a reading from the main area of lighting. Be sure it is permissible to take a camera into an auditorium before taking pictures. In some cases it may be advisable to attend a rehearsal to get the best pictures.
Right: Dancers can be spectacular to photograph, as is demonstrated by this colourful shot.
Below: Look for candid shots of audiences at events.

characters. But make sure your attentions are welcome, because, while some are only too pleased to be the centre of attraction, many turn out to be shy of any sort of publicity. One of the best times to shoot fairground pictures is in the early evening, when the fairground lights are on and there is still enough daylight, although you might need a fast film. If you want to freeze the action on the fairground rides, you will need a shutter speed of 1/500 sec or faster for most of them. Or you might be able to position yourself so that you catch the movement as it comes towards you. On the other hand, for special 'blurred' effects, you can try a slower speed of say 1/15 or 1/30 sec.

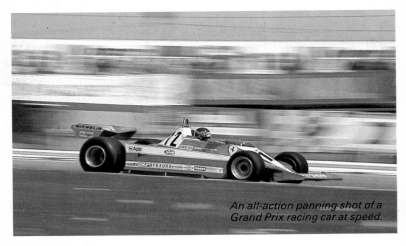

An all-action panning shot of a Grand Prix racing car at speed.

Sports Action

Most sports are fast-moving and exciting. Sports photography can be equally as exciting, but above all you need patience – and lots of film.

Many people who are interested in a particular sport naturally progress to photographing it. Certainly, it helps to have some background knowledge so that you can select the right places to record the action.

For example, in a horse race the best action may be at a particular fence, or in a motor event, a tricky bend may produce the most spectacular race shots. In such sports, once you have determined the best positions, you can snap away happily and consistently, and predictably get good shots. It is just as easy to catch a tennis player serving, say, but to catch a diving volley at the net needs more expertise. And to capture exciting action in a sport such as soccer, where the play is far less predictable, needs quick reflexes, too, and often a certain amount of luck.

Look out at sporting events for action not in the 'spotlight', such as two rugby players having a tussle with each other while the ball is at the other end of the pitch. Such incidents often provide some of the best 'sporting' pictures.

Equipment

For most sports photography, an SLR camera is essential, because you will need lenses of different focal lengths and other accessories. It is often difficult or impossible to get close enough to sporting action without a telephoto lens – a 135mm is probably most useful, although lenses of perhaps 200mm or longer may be required.

Many photographers find a zoom lens – say 80-250mm – ideal for sport because the focal length can be adjusted at a touch. This saves you time changing lenses and possibly missing important shots, and reduces the equipment you have to carry.

Some cameras can be fitted with an autowinder or a motordrive. Either of these devices automatically winds the film on to the next frame and enables you to take a quick sequence of shots. Most autowinders have a shooting speed of about 2½ frames per second, while motordrives are much faster, about 5 frames per second. Motordrives are relatively expensive, but most autowinders cost no more than a cheap lens.

Another useful accessory in sports photography is a rifle-grip. This fits onto your shoulder so that you can support the camera and hold it just like a rifle. A special trigger is connected to the camera's shutter button via a cable release, and the whole grip combines fast shooting ability with firm support.

Below: This dramatic cricketing picture shows that not all the action goes on at the batting end. Using a long mirror lens, the photographer pre-focused on the wicket and waited until the bowler reached it before firing the camera. Patrick Eager.

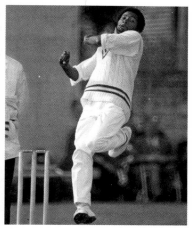

Above: Gymnastics is perhaps one of the most graceful sports to photograph. Ed Lacey.

A shutter speed of 1/500 or 1/1,000 sec is often needed to freeze fast sports action. So is a fast film – 400 ASA should be sufficient for most situations, although in bad light or with floodlit events it might have to be 'uprated'.

Panning

The effect of 'panning' involves following a fast-moving object with the camera and capturing a sharp image of it, while making the background blurred and 'streaky' to suggest movement. It is a technique that requires lots of practice.

Suppose you are photographing a moving car. The first thing to do is pre-focus on the spot where you are going to 'catch' the car – this saves any fiddling with focusing later. Then, as the car approaches, follow it along, keeping it in the centre of the viewfinder. As it reaches the spot, fire the shutter – but keep the camera moving to complete the 'follow-through'. To get the best effect, use a slow shutter speed – about 1/30 sec. But, experiment with speeds, because the effect depends very much on the speed of the moving object.

Holidays and Travel

Travel offers the photographer the opportunity to capture many new and exciting photographs. A new location can be like a breath of fresh air. And sometimes there may be so much to photograph that it is difficult to know which way to point the camera first. Without thinking, a 'trigger-happy' photographer will soon use up lots of film and perhaps come back with a collection of uninteresting images.

Holiday snaps apart, with popular tourist attractions it is often better to buy a postcard! Professional photographers spend months trying to capture the ideal shot of a particular scene, and you would probably be hard-pressed to better that. But go for the unusual angle, or pick out interesting parts of a particular building or view. Or, you might photograph a local character and simply use the scene as the backdrop.

Local people express the feeling of a place, so keep an eye out for interesting faces. Street fairs, markets, and carnivals are where you are likely to capture local activity best. Look for a variety of pictures when travelling. Apart from the scenic views and places of interest, there are the shops and the forms of transport, even sometimes the street signs, that say something about a foreign country.

Travel Tips

The roving photographer needs to travel light. One camera bag, containing a camera and perhaps three lenses, lens-cleaning material, a small flashgun, and spare batteries, should be sufficient. And, of course,

plenty of film – it might be more expensive abroad.

Most airports now use X-ray equipment for checking baggage. Many machines do not harm film, but it is safer to request a hand search. Or you could carry your film in a special lead-lined bag now available to protect it against X-ray damage. Customs men may also insist on looking inside the camera, so make sure it is empty when passing through checks.

Look out for interesting characters to photograph when travelling, such as this Cypriot peasant family.

Before going abroad, always make sure your equipment is covered against loss or damage. Camera insurance might be included on an existing household contents policy, but you may need to take out special cover.

Beaches

Most beaches are full of interesting and often unusual picture possi-

Above: A low shooting angle has emphasized the size of this statue. Above right: It isn't always local people who express the atmosphere of a place – a Japanese artist on the banks of the Seine. Right: An ingenious shot of nets and ropes in a fishing port.

bilities. People relaxing and playing make fascinating character studies. Try using a telephoto lens to catch them unawares. Children playing with sand can provide an interesting sequence of shots.

With a long telephoto lens, you can take people in the sea. Surfing, in particular, provides some very dramatic pictures, and experience will tell you what to look for.

Photographing people on a brightly lit beach presents some exposure problems. The light-meter will take readings from the bright sand areas, causing a person's features to be underexposed. To overcome this, move in close, take the reading from the subject's face, and then move back to reframe and focus the shot. A more correct ex-posure should result, although the background may be slightly over-exposed.

Camera Care

Before setting off on holiday, check your camera equipment. If the camera has been gathering dust in a cupboard all winter, check that everything on it is working. Try a film through it, if you have time, or have the camera checked and, if necessary, serviced.

On beaches, keep the camera in a case when it is not in use, or in a plastic bag. Sand and grit can easily damage the mechanics. And never leave the camera or films in hot sunlight. Wrap them in a plastic bag and keep them in a cooler box if you have one.

Landscapes

Your initial view of a landscape might not always be the best for a photograph. If possible, try a few different viewpoints. It might be preferable to find a higher vantage point for the shot, perhaps on a hill. In that way, you could look down on the view and eliminate unnecessary sky area in the shot. Of course, if the sky features a particularly interesting cloud formation, or even if it is simply a pleasing colour, you may wish to include more sky than normal for effect.

Always consider what you may want to include in a picture – a winding path leading to a tree-lined avenue, perhaps, or fields leading up to a mountain, You use this kind of foreground to lead the viewer's eyes to a central point in the picture. Overhanging trees can give an 'edge' or frame to a picture. Bear in mind that the foreground should be as subtle as possible so as not to detract from the overall view.

Take care with exposures. A general light reading might lead to underexposure of ground detail. You will get a truer reading if you tilt the camera (or hand-held meter) downwards. Sometimes, deliberate under- or overexposure can create an interesting effect; underexposing to darken sky and ground areas and create a moody effect, or overexposing to create a bright, hazy-looking landscape.

A good set of lenses is important for landscape work. A wide-angle lens will enable you to take in all of the view, and a long telephoto lens to pick out details. You will also need a wide range of filters: for black and white work, a green filter to lighten foliage, yellow to darken a sky, orange and red for dramatic effects; for colour work, a skylight filter to help eliminate ultraviolet haze and a polarizing filter to darken a blue sky and increase the strength of the landscape colours.

Left: Many photographers think of taking only distant landscapes. Here the emphasis on foreground detail, with the beach stones dominating the picture. The strong, directional lighting makes the stones stand out, adding extra texture.
Opposite page, above: The appearance of a horse and cart adds extra romance to this 'sunset'.
Right: Two very different landscapes, although both offer an upright, rather than a view, picture.

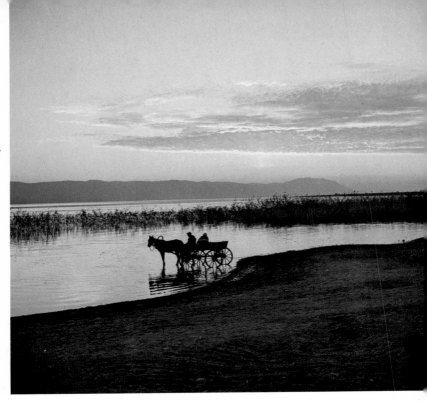

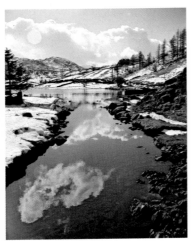

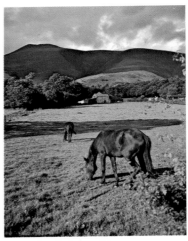

Buildings and Architecture

When photographing architecture, it is very difficult (and not necessarily desirable) to isolate it from its natural surroundings. Your photographs are, in effect, a kind of urban landscape. The shape and design of buildings say something about their environment. Indeed, many cities can be identified by their architecture.

Although it may often be necessary to take 'straight' photographs of architecture, for record purposes, say, it is more challenging to try a personal approach, looking perhaps for an unusual aspect. Viewpoint is a major factor when taking pictures of buildings, and you should try many different angles. You may decide to use a wide-angle lens, to take in the whole expanse, or a telephoto lens to view the building from a distance. The latter approach helps to compress the view and eliminate any foreground or background clutter. It may be possible to take your pictures from a high building nearby.

When photographing tall buildings from a low vantage point or with a wide-angle lens, the sides of the

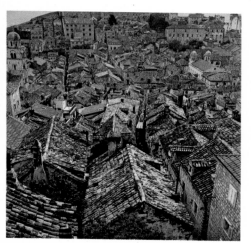

Left: The colourful roof-tops of Dubrovnik make a fascinating subject for the architectural photographer.
Below left: For this shot of a house, the building was framed in an old wooden archway.
Below: Old ruins make interesting subjects. A low shooting angle emphasizes the slightly elevated position of this old building.

Opposite page: Church interiors are full of fascinating and intricate detail.

building may appear to bend inwards, or converge. On some cameras, a *shift lens* (a lens of adjustable elements) can be used to overcome this problem. On a large bellows camera, the front or back sections can be tilted to straighten out these *converging verticals*.

Many buildings feature interesting carvings or murals, and to capture this detail you need to move in close. A standard camera lens might do, although you are more likely to need a telephoto lens.

Much modern architecture features bold, sweeping lines, where the emphasis is more on shape than on intricate design, and by choosing the right angle, you can use shape to its best effect. And with a very wide-angle lens you can distort the shape of a building for special effect.

One way to add interest to an architectural shot is to 'frame' the building, perhaps viewing it through an archway or a window. A row of

trees in front of the structure might relieve the monotony of too much stone or concrete. If there are no trees around, you can hold a branch just in front of the camera to create a similar effect.

Interiors

Daylight coming in through windows gives the most natural effect to an interior shot. The relatively low light level, however, may dictate the use of a slow shutter speed, so take a tripod.

For smaller interiors, say the size of an average room, flash or simple lamp lighting might be sufficient. But for larger spaces, such as the inside of a church, many lamps may be needed to do the job, particularly where there are awkward corners. Alternatively, leave the camera shutter open on the 'B' setting and use one bright lamp to 'paint' the whole area with light so that each part is lit evenly.

Nature and Close-ups

Nature provides a wealth of intriguing picture opportunities – animals, birds, insects, trees, flowers. And although the photographer does not have to be an expert naturalist, it is helpful to have at least a little knowledge of the subject (and indeed many naturalists become excellent photographers). Knowing about a particular bird's nesting habits, for example, will enable you to plan when and where to take your pictures, often saving a long and unfruitful wait.

Equipment

For most nature photography, you will need an SLR. The type of lenses will depend largely on the subject. With birds, for example, you must use a very long telephoto lens for close-up shots to avoid frightening them. To record details of flowers and insects, you need special close-up equipment.

A *macro lens* features a very close-up focusing facility as well as a 'normal' focusing range. Many zoom lenses offer this feature. *Extension tubes* are a set of hollow metal tubes (usually three) that fit between the camera body and the lens. The degree of magnification (usually up

Above: 'Tomato clowns' and tropical sea anemone. An example of highly specialized technique. Heather Angel. *Left: You don't always need special equipment to take nature pictures. This shot was taken with a standard lens.*

to ×3) depends on how many of the tubes are used. They are available on most SLR camera fittings and are quite inexpensive. A *bellows extension* can be adjusted to vary the degree of magnification and for very fine focusing. This is a relatively expensive type of close-up attachment, depending on the fitting. *Close-up lenses* can be fitted to most SLR and 35mm compact cameras. They simply screw onto the front of the lens (like a filter) to enable close

focusing. But they produce a certain amount of image distortion, particularly at wider apertures.

You will need a tripod, particularly when a heavy lens is being used, or in close-up work where the slightest camera movement can throw the image out of focus. A special air-release, or even an electronic remote-control device, can be used to fire the camera shutter from a distance, so that you do not have to disturb the subject. If you use the remote release in conjunction with an autowinder or motordrive (to wind the film on automatically), the camera can operate unattended.

Lighting

Natural daylight is adequate for most nature photography, with the help, if necessary, of silver paper or

This Zebra butterfly fired the camera itself by breaking an infra-red beam. As a result it is caught at just the right moment. Stephen Dalton.

white card to reflect light onto specific areas. You will need flash in very low light, or to 'freeze' fast-moving insects, and of course for taking nocturnal animals. For specialist work, there is an infra-red flashgun, which, in conjunction with infra-red film is used to throw out a light invisible to the naked eye. In this way you do not disturb the animal with a sudden burst of light.

It is also possible to set up nature photographs indoors, using lamps or flash. Here, you have full control of lighting and backgrounds. although the results may lack the mood of the natural surroundings.

Animals

Most animals move quickly and unpredictably, so the successful animal photographer has to develop not only an eye for good animal pictures, but also the reflexes to capture them.

Familiarity with your equipment is essential, and it is advisable to travel light so that you can move around and photograph more quickly. Give careful thought to lenses, bearing in mind that, with most animals, you will not be able to work very close. You will need a long, or very long, telephoto lens, and use a monopod (one-legged tripod) to give extra support to the camera.

An open-enclosure shot. Canon, 200mm lens, 1/250sec, f/8, Tri-X.

In the Wild

To photograph animals in their natural surroundings is challenging and often difficult. In this kind of situation, the photographer is very much the intruder, while the animal is on home ground – so find out about your subject's habits. At feeding time, for instance, some animals are more likely to be too preoccupied with eating to notice your intrusion. It is a good plan to consult a friendly animal expert, and perhaps invite him along.

It is often necessary to see the animals without their seeing you. Take up a position in some bushes, perhaps, or behind some trees, or photograph from inside a tent. You may find it worth while to construct

a special hide with plenty of holes in it so that photographs can be taken from any angle (moving the hide around might disturb the wildlife). But be prepared for a long wait. Several days' shooting may produce only a few successful animal pictures. Patience, rather than skill, is the wildlife photographer's main attribute.

In the Zoo

Although it is easier to photograph animals in the zoo than in the wild, there are still restrictions to be overcome. Many animals are housed in caged enclosures. But by using a telephoto lens (80mm or longer), focusing on the subject, and using a wide lens aperture (to minimize depth of field), you can eliminate the bars. The farther away the

These fieldmice were photographed using flash at night.

animal is from the bars, the more successful the shot is likely to be.

Some of the best zoo animal pictures are taken at feeding times. Normally docile animals come alive when there is food around, so this is a good time to catch them in action. Special activities, such as elephants' bath time, are also fun to photograph.

In the Wildlife Park

Wildlife parks enable you to photograph exotic species in an open environment. In many parks, you can take pictures from a car, although you may not be allowed to wind down the window. In this case use a polarizing filter over the lens to reduce reflections. A dark cloth, or coat, held behind you will also help to absorb any reflections.

You will need a long telephoto lens to take distant animals, but many of the more docile creatures are apt to wander quite close and perhaps climb all over the car. Some parks also have special viewing enclosures where the photographer can take pictures safely.

A pleasing shot of an occupied giraffe. Canon, 200mm lens, Ektachrome.

Fashion

In fashion photography, the main idea is to show off the clothes, although other factors, such as choice of model, lighting, and location, all influence the final result.

Most fashion work requires only simple and direct lighting to show the cut and texture of the garments being modelled. Studio flash is often best for fashion because it is fast and easy to operate. And it provides very consistent results, an essential factor when a sequence of shots has to be taken. A white umbrella, fitted to each studio unit, bounces a

onto the model. (It produces a rim shadow if the model is close to a background.) Most ring-flash units are expensive, but a similar effect may be produced with a small flash-gun on either side of the lens.

For some fashion photography, a plain studio background may be all that is required. But be careful to choose the right colour to complement the clothes. Outdoor locations are usually more suitable for casual clothes.

Many magazines go in for 'action' fashion pictures, where the models are involved in some activity, such

In some fashion pictures it is necessary to create the sort of mood that the clothes suggest. Here the photographer has used a soft-focus effect to accentuate the girl's soft white gown.

soft, even light onto the subject, showing the texture of the clothes to its best effect. One or two units may be placed close to the camera for direct lighting, or farther apart for more pronounced side-lighting.

Ring flash is used in a lot of modern fashion work. A circular flash tube, it fits around the camera lens, and throws a hard, direct light

as walking briskly across the set, perhaps to show off a swirly dress. Special props, such as handbags or scarves, may be added for extra interest and colour.

When posing fashion pictures try for some variety, taking full-length shots as well as close-ups. Changing the model's hair or make-up may also add interest to a series of shots.

Glamour

Most glamour work is an extension of portraiture – only in this case the photographer is concerned with photographing the female form. Glamour photography often looks a lot easier than it actually is. But it requires a lot of skill and patience from both photographer and model.

The key factor with any session is preparation. If you are using a studio, set up the camera and lighting beforehand and check exposures where possible. This will save time when the model arrives.

An experienced model will know about poses and understand a photographer's general requirements. But you should give her a brief outline of the specific pictures required before the session starts. With an inexperienced model, you might have to spend a little time to put her at ease. A coffee or background music will help to relax her.

Most glamour work can be handled with simple lighting set-ups, perhaps a couple of studio flash units. For more subtle pictures, where the emphasis may be more on shape, back- or sidelighting may be needed. Backlighting can also be used effectively to rim-light the model's hair and add pleasing highlight detail to the shot.

Props are used in glamour photography to add extra interest where needed – from a necklace to a sofa.

Top: Glamour does not always mean full-length shots. Soft umbrella flash has been used to light the subject's face, while a strong back light adds a bright rim to the hair. Left: Simple side lighting and a relaxed pose.
Colin Ramsay.

Shape, Pattern and Texture

Every object you choose to photograph will contain some form of shape, pattern, or texture. These elements tell a great deal about an object and give the photograph depth. Such details as the shape of a tree in a landscape, the pattern of colours in a mosaic, or the texture of a person's skin all say something.

Shape is often the dominant factor in a photograph. Even when taking pictures of simple objects, such as a set of wine bottles, it is the shape rather than the colour or texture of the objects that makes them identifiable.

The effect of shape can be shown quite simply by photographing objects in silhouette. Using back-lighting, say from a window, an object can be thrown into silhouette and identified by its shape alone. A silhouette of a person's face may still be recognizable through the shape of the profile.

Quite often the photographer may come across good examples of shape and not realize the picture possibilities. It is usually a matter of viewpoint or perspective. For example, a distant view of a church may be bettered if you move in close to photograph the interesting shape of an archway, or of the spire. Choice of lens is important too. A wide-angle lens might, for example,

Above: Even everyday objects you might find around the home can make interesting pictures when photographed in an unusual way. This corroded drain filter was photographed close up, using extension tubes. Strong side lighting has emphasized the hard, rusty texture of the filter.

Left: A picture like this involves imagination rather than technique. The fascinating shapes and colour of the bubbles show up beautifully against the dark background.

distort the shape of a piece of architecture, or a telephoto lens might be used to pick out the outline of a tree.

As shape will be included in virtually everything you photograph, you should cultivate the habit of thinking about it when composing your pictures. As you look through the camera viewfinder, think about the shape of the subject and how it fits in with the general composition.

Pattern and texture on the other hand, express what the object is actually made of. Pattern is a strong visual communicator in a photograph, blending such elements as colour, lighting, and design. You will come across countless natural forms of pattern – the intricate markings on a leaf, the different types of fields and vegetation in a landscape, the ripples on water, and so on. Pattern may also be 'man-made', such as detailed paintwork on a building or the contours of a cobbled street.

With texture, the photographer has the difficult task of expressing how the object might feel if the viewer could touch it. In visual terms, this might mean producing a kind of three-dimensional effect so that the object appears to have depth. You can achieve this by careful lighting, mainly from the side of the object, so that the shadows and highlights in the picture give the illusion of depth. Side-lighting produces shadows if there are any irregularities in the object's surface. For this reason, it is important to choose the right time of day when photographing texture detail outside. Early morning or late evening is best, when the light is usually harsh and directional.

Above: The peeling paint of an old beach hut makes an eye-catching picture. Canon, 200mm zoom lens set in close-up 'macro' position, 1/125sec, f/8, Ektachrome.
Left: Grainy wood pattern of an old log cabin. Geoff Prestwich.

The Studio

The average enthusiast does not have the space for a special studio, but it is possible to set up a simple arrangement, perhaps in a spare room or an outhouse.

For still-life photography, only a small set-up is required, perhaps in the corner of a room. When using artificial light, you may have to use black-out material on the windows to prevent extraneous light from affecting the result. If the objects are set up on a table, you can create an even background by curving some background paper behind.

Left: David Bailey's picture of Jean Shrimpton shows his distinctive studio lighting approach.
Below: A range of modern electronic studio lighting equipment.
Above right: Simple lighting was used for this vase shot.

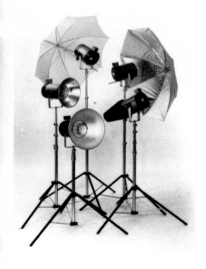

More space is needed for portraiture. It is a good idea to choose a wall opposite a door, which can be opened to allow you more scope for, say, a full-length portrait. The background is important. White is generally 'safe' for most work.

Most studios require only a very simple lighting set-up. This might include a *main lamp*, with a large 'dish' reflector to spread the light evenly; a smaller *second lamp*, used to add extra 'fill-in' lighting; and a *spotlight*, to give an adjustable spread of light.

How the lights are positioned will depend on the type of shot. For a straightforward portrait, set the main lamp just to the right and slightly above the camera, with the second light to the left to fill in the shadow areas. The spotlight may be placed behind and to the side of the subject for backlighting. Experiment with lighting for each subject.

Studio flash, a popular light source for studio work, produces fast, consistent lighting without the overbearing heat that can be caused by lamps. Most studio flash units have built-in modelling lamps which light the subject (for focusing, etc.) before the flash is fired.

The Darkroom

Setting Up

If you send your films away for processing, you miss out on half the fun of photography. In many ways, processing your own films is just as exciting as taking pictures – which is why having your own darkroom is such an asset.

Although ideally it is best to have a room specially set up for processing and printing, it is not always possible. You can process a film without a darkroom by using a *changing bag* – a light-tight bag, with elasticated armholes, which is used when loading film into a developing tank. The operation can be

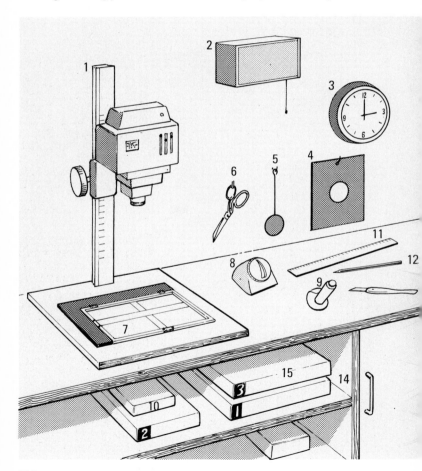

carried out in normal light (no light enters the bag), the loaded tank then removed and the film processed.

For printing the film, you will need some kind of darkroom area, unless you are able to use the darkroom facilities of a camera club. If you do not have a spare room at home, you can set up in the bathroom, under the stairs, in the loft, or even in a large cupboard. Having

Dry bench (opposite page): 1 Enlarger, 2 Safelight, 3 Clock, 4 'Burner', 5 'Dodger', 6 Scissors, 7 Print easel, 8 Timer, 9 Focus magnifier, 10 Tape, 11 Ruler, 12 Pen, 13 Scalpel, 14 Storage shelves, 15 Photographic paper. Wet bench (below): 16 Chemicals, 17 Developing tank, 18 Stirring rod, 19 Mixing jug, 20 Spirals, 21 Thermometer, 22 Paper towels, 23 Film squeegee, 24 Print trays, 25 Print tongs, 26 Water filter, 27 Sponge, 28 Print squeegee, 29 Bin.

everything in one room is convenient but not always practical. You may find you have to set up the enlarger in one place and perhaps do the processing and printing in a kitchen or somewhere else that has running water. Either way, the darkroom should have two separate areas – a *dry bench*, for enlarger and other equipment, and a *wet bench*, for processing the prints. For safety's sake it is advisable *not* to have electrical equipment too near the wet bench. If in doubt, ask an electrician for advice.

Dry Bench

The dry bench in the darkroom is essentially where most of the printing work is done, and an electrical point is required for the enlarger, safelight, and other equipment. A bench with shelves underneath (or a large cupboard) is ideal for work surface and storage.

Your choice of enlarger will depend on the type of work you are doing and how much you have to spend. Models vary from a simple enlarger that packs away into a carrying case after use, to sophisticated pieces of equipment for colour work. You can buy a good enlarger for the price of a cheap SLR camera. But it is worth equipping it with a good lens if you want to produce the best results.

Although it is possible to time exposures with a watch, it is more efficient to use a special timer, either mechanical or electronic, and preferably with a luminous face. An orange safelight (which does not harm black and white photographic paper) in the dry-bench area will enable you to see what you are doing.

Because you will be handling negatives in this dry-bench area, it is essential to keep it clean. Any dust or dirt on the negative will show up on the print. If the enlarger is left standing, keep a dust-cover over it, and clean the negative carrier with a blower brush before use.

Wet Bench

The wet bench is where all the film and paper processing takes place. Be careful with the layout here, because you may often be working in total darkness. Avoid leaving things in awkward places, or surfaces jutting out. Familiarize yourself with the layout, and keep everything in its place. In this way you will avoid the 'darkroom panic' that can so easily grip you when you cannot find something you need in a hurry.

Items such as chemicals, processing tanks, and dishes should be kept on shelves near the main worktop. A work surface of Formica or similar material is ideal so that it can easily be kept clean. The print trays should be laid out in the order of use – developer, stop-bath, fixer – clearly labelled, and always used for the same purpose. Solidified fixer in a dish that has not been properly washed can easily contaminate a developer placed in it. Anyway, all trays should be emptied and washed after use. Any developer left out will quickly oxidize and eventually become useless. If possible, have some kind of ventilation near the wet-bench area because of the hazard of chemical fumes.

A special print washer is available for removing chemical residue from prints. Or you can wash prints with water in a sink.

Processing Black and White Film

To process a black and white film you will need the following basic items: a developing tank, film spiral, thermometer, chemicals, measuring cylinders, a clock (or watch), and a pair of scissors.

The developing tank is the essential item in this list. Plastic tanks and spirals are normally the easiest to use, although special stainless steel tanks are also available. In the case of the latter, the spiral is loaded in a slightly different way.

The size of the tank depends on how many films you wish to process at once. The tank shown below takes three 35mm films at once, but smaller and larger tanks are available. The plastic spiral is adjustable to take 35mm, 127, 126, and 120 size films.

Chemicals

There are three chemicals used in processing black and white film: developer, stop-bath, and fixer.

Developer. When the film is exposed in the camera, a 'latent' image is formed. The image cannot be seen, but it has to be amplified chemically – by the developer. The developing 'agent' converts the exposed silver halides in the film emulsion to visible black metallic silver.

Stop-bath. This chemical stops the action of the developer immediately. It also prevents the fixer from becoming contaminated by the developer.

Fixer. This gets rid of the undeveloped silver halides on the

The plastic tank and film spiral. This particular tank has a capacity for three 35mm films. When the films are loaded into each spiral, the spirals are loaded onto the stem, the holding ring is attached, and the lid replaced. The unit is then completely light-tight.

image emulsion and makes the image permanent.

After fixing, the film is washed thoroughly and dried.

Note: Because films come in different types and speeds (ASA), there are particular developers to process them. For most medium-speed films (around 125 ASA), use a general-purpose developer; for slow films (50 ASA or less), use a fine-grain developer for fine results and maximum image detail; for fast films (400 ASA plus), a high-speed developer will allow maximum speed from the film. Some manufacturers recommend the use of a particular developer with a specific film.

Loading the Tank
1. *Trim the edge of the film leader with a pair of scissors to make loading easier. If the leader has been completely rewound into the cassette, this has to be done when the cassette is opened.* **2.** *IN TOTAL DARKNESS. Turn the film cassette upside-down and tap it gently on the bench until the base comes off. Use a bottle opener or special cassette opener if necessary.*
3. *Place the end of the film in the spiral. Gently rotate the two halves back and forth until the film is loaded. Cut off the cassette centrepiece.*
4. *Load each spiral onto the tank stem. Attach the holding clip to secure the spirals, and place them in the tank. Secure the lid firmly. (The lights may now be switched on.)*

Processing
5. *Fill the large measuring cylinder with water to the correct temperature (usually 68°F). Measure the required amount of developer into a pipette, add it to the water, and re-check temperature.*
6. *Pour developer into tank. (Tilt the tank slightly when pouring in chemicals, otherwise it may overflow.) Replace*

lid cap. Set clock to time development.

7. To ensure that each part of the film is covered with developing solution, agitate the tank for the first 30 seconds. Invert and turn the tank for even coverage. Agitate for about 10 seconds per minute during development (see instructions). **8.** Remove lid cap and drain away developer. (Pour back the solution if it is re-usable.) **9.** Pour stop-bath solution into tank. Replace lid cap and invert the tank to ensure the film is covered. After 10 seconds or so, pour the solution back into the bottle. **10.** Pour in a pre-measured amount of fixer, replace the lid cap, and agitate. Follow the recommended fixing time (usually a couple of minutes). After fixing, it is safe to open the tank and check that the films have 'cleared' (they will be a pink colour if they haven't). **11.** If so, replace lid and attach water hose to wash films (usually 20–30 min). A hose with water filter will prevent lime deposits forming on the films. **12.** Take the spirals out of the tank and remove each film carefully. **13.** Remove excess water from film to prevent 'blobs' or drying marks forming on emulsion. (Use a pair of film squeegees, or forefinger and middle finger clasped together. Take care not to scratch the emulsion.) **14.** Attach special film clips to each end of the film. Hang in a drier, or on a line in a dust-free room.

7

8

9

10

11

12

13

14

Black and White Printing

Contact Printing

After the film is processed it appears in *negative* form – that is, whites appear as blacks, and vice versa. To see the results in a *positive* form, it is necessary to make a print.

The quickest way to assess the negatives is to make a *contact* print. The negatives are cut into strips and placed on a single sheet of photographic paper. After processing the paper, you can view the results in positive form, and see at a glance which negatives to select for enlargement.

Note: Photographic paper may be handled safely under orange or red safelights. Keep it in a light-tight box when ordinary room lighting is on.

Contact Printing

1. *Place a sheet of photographic paper (emulsion side up) under the enlarger and place the negatives on top (dull side downwards), in strips. Cover with a sheet of clean glass. Swing the red filter over and switch on. Adjust the height of the enlarger until the light evenly covers the paper. Remove filter, time exposure, and replace filter. Switch off, and remove paper.* **2.** *Check temperature (about 68°F) of the processing chemicals – developer, stop-bath, and fixer.* **3.** *Place paper face down in developer. Start timing.* **4.** *To ensure even development, agitate by rocking.* **5.** *After a short while the image will begin to appear.* **6.** *A few seconds before development time is up, remove print from solution and allow it to drain. Then place the print face up in the stop-bath and agitate for about 10 seconds.* **7.** *Remove the print, drain it, then place it face up in the fixer and agitate until surface is*

covered with solution. Fix
for the recommended
time (2–5 mins). The
room lights may now be
switched on. (Make sure
all paper boxes are closed
first.) **8.** After fixing, the
print is washed and dried.
Resin-coated papers need
only a quick wash (2 mins)
and will dry naturally at
room temperature.
Ordinary Bromide papers
must be washed for 20–30
mins and dried on a
flat-bed drier, or glazer
(glossy paper). **9.** Once
dry, the contact print may
be viewed critically.

7

8

9

Making an Enlargement

In room lighting. *Clean
negatives with blower
brush to remove any dust
or dirt from emulsion.
Any spots on negative
surface will show up as
white spots on the print.
Place negative in the
enlarger's negative
carrier (left). Make sure
negatives are placed flat
into the carrier – if they
are not flat, parts of the
print will appear out of
focus. Move carrier into
the enlarger.*

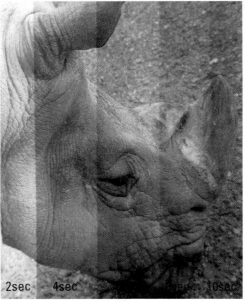

2sec 4sec 10sec

Making an Enlargement

(continued)

In safelights. **1.** *Switch room lighting off and safelights on, and switch enlarger on. Open enlarger lens to its widest aperture so that a clear bright image appears on printing easel. Adjust height and focusing until image is correctly framed in easel.* **2.** *Switch off enlarger and place printing paper in easel. The easel should be adjusted to relative size of the paper – eg 25 × 20cm (10 × 8in), leaving a border if required. Stop down the lens to f/8 or f/11.* **3.** *Make a test strip to determine correct exposure. This involves exposing whole area of paper for about 2 sec, then moving piece of opaque card along paper at further 2 sec intervals. After about 10 sec, switch off enlarger and remove paper.* **4.** *Place paper in developing tray and process (as for contact print). The results should be a series of bands, going from light to dark, across surface of print. Each band denotes a particular exposure time.* **5.** *Look at test strip in normal room lighting and select required exposure time – in this case, 6 sec. Switch off room lights, expose sheet of paper for selected time, and process paper in normal way. The result should be a correctly exposed print.*

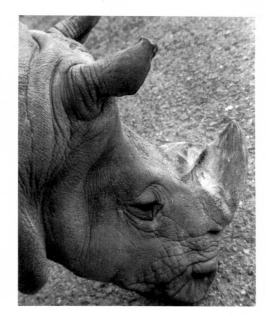

Paper grades. *Photographic papers are available in different grades. The print at the top left was made on Grade 1 paper and is too 'soft'. The print above left was made on Grade 4* paper and is far too contrasty and 'hard'. The print on the right, made on Grade 2 paper, shows medium contrast and good tones and is 'correct' for this particular negative.

Darkroom Techniques and Effects

Apart from choice of the grade of paper and varying the time of processing, you can affect the final results in other ways in the darkroom. Not every negative has a perfect balance of highlight and shadow detail, for example. At the printing stage, parts of the print may look either too bright or too dark. So a little manipulation may be necessary during the exposure of the print.

First make a 'straight' print and

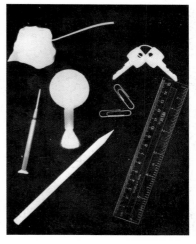

To make a photogram (right), simply place items of various shapes on a sheet of photographic paper, expose to white light, and process.

decide which parts of it need extra exposure, and which parts need less. Where the shadow detail is too dark in the print, it can be lightened by *shading* that area of the print from the enlarger light during part of the exposure time. You can use your hand, or a piece of black card, for most shading. For small areas of the print, you can try a procedure called *dodging*. For this you need a small piece of card stuck to the end of a long, thin wire or a knitting needle. Cut the card to roughly the shape of the area to be dodged, and hold it over that area (just a few centimetres below the enlarger lens) during exposure. Keep it moving slightly so that harsh edges of the card don't appear around the dodged area.

In a print where the highlight areas are too bright, you can try *burning-in* to increase the detail. You do this with a piece of card (about the size of the print) with a small hole cut in it. Expose the overall print for the required time and then expose again with the card hole held over the area that needs extra exposure. Again, hold the card a few centimetres below the enlarger lens and keep it moving during the burning-in time.

Be careful always not to overdo dodging or burning-in on a print; otherwise the effect is likely to look artificial.

Dodging. *The picture on the far left is a 'straight' print from the negative. The overall exposure is about right, except for the statue carvings, which are too dark. For the second print, a 'dodger' (piece of card on the end of a wire) was held briefly over this area during the exposure to lighten the detail.*

Burning-in. *In the left-hand picture, some areas of the swan's plumage appear too light. For the second print, a normal overall exposure was given and then extra exposure was added to the light area. A piece of black card with a small hole in it was used for this 'burning-in' process.*

Processing Colour-Slide Film

Most colour-slide films can be home-processed. Although slightly more complicated than black and white work, colour-slide processing can easily be tackled using one of the many special kits available.

Slide film has one great advantage in that, once it has been processed and dried, it can be cut up and mounted ready for viewing or projection. There is no complicated printing stage.

There are basically two types of colour-slide film. *Substantive* films, such as Ektachrome, contain dye-couplers (which form the colour image) in the emulsion, and can be processed at home. Most are compatible with the Kodak E6 process described below. *Non-substantive* films, such as Kodachrome, have to be returned to the manufacturers for processing, because the dye couplers are contained in their chemicals.

The E6 process, which is available in easy-to-use kit form from several manufacturers, requires high operating temperatures (around 38°C) that have to be maintained rigidly during the process. This can be done by creating a water jacket (such as a washing-up bowl) to keep the chemicals warm. However, at least one kit, made by the 3M company, has a working temperature of 20°C (as for black and white), which is easier to operate, particularly if no warm water is available in the dark-room.

Some slide films are compatible with the older Kodak E4 process. During this process, the film has to be re-exposed to white light in order to reverse the image. In the E6 process, this 'fogging' is done by a chemical.

E6 Process

The kits available for E6 process films vary slightly, so it is essential to read the instructions before starting. The particular run-down here is for Kodak's own E6 kit.

Apart from the chemicals in the kit, you will need the following equipment:

A small processing tank and spirals

Seven measuring cylinders (600ml)

An accurate thermometer

Seven storage bottles (600ml)

Mix the chemicals as directed and place the containers in the water jacket at about 42°C. By the time the first colour developer is needed, the jacket will have cooled to about 38°C. During the process, agitate as recommended in the kit instructions, and follow temperature and time details carefully – they are more critical than for black and white.

Step 1: First developer; 7 min. This produces a negative black and white image on the film.

Step 2: Wash; 1 min. Use a pre-heated supply of water (33-39°C) to remove the first developer.

Step 3: Wash; 1 min. Repeat step 2 to ensure complete wash.

Step 4: Reversal bath; 2 min. The colour emulsion is fogged to form a latent colour image.

The following steps can be carried out in normal room lighting:

Step 5: Colour developer; 6 min. This develops the latent colour image.

Step 6: Conditioner; 2 min. This

chemical prepares the film for bleaching.

Step 7: Bleach; 7 min. The original black and white image is no longer needed on the film and is bleached away leaving just the colour image.

Step 8: Fixer; 4 min. This dissolves unwanted salts on the film.

Step 9: Wash in running water; 6 min. To remove all remaining chemicals on the film. Connect a two-way hose to hot and cold taps for correct running temperature.

Step 10: Stabilizer; 1 min. Makes the film image permanent.

Step 11: Hang the films in a dust-free environment and wipe clean with a clean chamois leather. When using a drying cabinet with hot air, do not allow the temperature to exceed 49°C.

Safety note: Take care when handling processing chemicals. Wear rubber gloves and avoid breathing in vapours from the solutions.

Processing Colour-Negative Film

Nearly all colour-negative films can be processed at home. However, once the film has been processed, prints have to be made from the negatives, so an enlarger and print-processing equipment are needed.

Most colour-negative films can be processed by Kodak's C-41 process, which can be bought in kit form. This is reasonably easy to use provided that you follow the instructions carefully. As with slide processing, pay particular attention to the timing of each stage of the process, the temperature of the chemicals, and tank agitation. Here is a brief run-down of the process:

Step 1: Colour developer (3¼ min)

Step 2: Bleach (6½ min)
Step 3: Wash (3¼ min)
Step 4: Fix (6½ min)
Step 5: Wash (3¼ min)
Step 6: Stabilizer (1½ min)
Step 7: Drying (time varies)

Recent developments in chemical technology have also produced much simpler processes for colour-negative film. For example, Photocolor II (made by Photo Technology Ltd.) is a two-step process, including only a colour developer and bleach/fix. The operation takes about six minutes and is as simple as black and white film processing. In addition, this process requires no awkward chemical preparation, and the solutions may be retained to process colour prints later.

Making Colour Prints

Colour printing has become much easier for the enthusiast over the years, thanks largely to the introduction of easy-to-use and inexpensive processing equipment.

Enlarger

Any enlarger can be used for colour printing provided that it has a filter drawer (a pull-out compartment that takes coloured gelatine filters). Filtration is important in colour enlarging to correct the colour in each individual print. Nowadays, special colour enlargers have built-in colour heads with 'dial-in' yellow, magenta, and cyan filters. The filtration needed for a particular type of colour paper can be adjusted on the dials. Constant illumination is also required during the exposure of colour prints, so a separate stabilizer is used to guard against voltage fluctuations.

Enthusiastic colour printers can

invest in a *colour analyser*, which measures exposure and colour filtration required for each print, thus saving valuable paper and chemicals – and printing time.

Processing

Until quite recently most home colour printing had to be done in trays (as with black and white). But the number of stages involved, and the difficulty in maintaining the correct temperatures, made the operation cumbersome. The introduction of special *print drums* has solved many of these problems.

Once the paper has been exposed, it is placed inside the drum and the lid is replaced. From then on, the process can be carried out in normal room lighting, much like film processing. The chemicals are added at the various stages and the drum is laid down and rolled to and fro so that the paper inside is evenly covered with chemicals.

To make processing even easier, special colour-printing kits are available that include motorized drum rollers that automatically rotate the drums. Some of these kits also have thermostatically controlled water jackets, so that all the chemicals can be kept at working temperature ready for use.

Prints from Colour Slides

You can make prints from slides as well as from negatives. For this, you need special *reversal* paper and chemicals.

One of the easiest methods of producing prints from slides is the Cibachrome A process (made by Ciba-Geigy). This is a four-step process, which takes about twelve minutes to complete, and requires reversal paper, chemicals, and print drum. These items may be obtained individually, although they have been available together in kit form.

Kodak also produces Ektachrome 14RC reversal paper and compatible chemicals. With this method, the processing time is about the same as for the Cibachrome process, but there are nine steps.

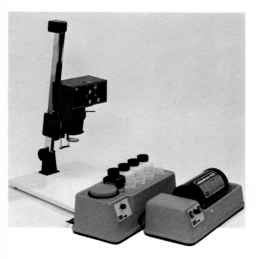

Until recently, most do-it-yourself colour printing was done by means of dish processing. But this was often impractical because of the number of solutions required. A drum processing kit, such as the Jobodrum unit shown here, is more practical. The exposed print is placed inside the drum and each solution is added when required. The drum is rotated by a motor to ensure that the chemicals cover the print surface evenly.

Presentation and Storage

A great deal of time and effort go into creating good photographs, so it obviously makes sense to present them properly and file them safely for future use.

All negatives and transparencies tend to deteriorate eventually, so storage is important. Try to keep them at average room temperature (20-21°C) in average humidity. Avoid damp or excessively hot places.

Mounting Transparencies
Many process-paid films are returned mounted after processing. But if you process your own films, there are a variety of mounts available, from simple card types to plastic mounts (some with glass sides). An advantage of plastic mounts is that they are strong and are unlikely to buckle in a projector.

Take great care when handling transparencies. Fingermarks can be very difficult to remove from the

film emulsion. Remove any dust from glass mounts with a blower brush before mounting.

Mounting and Framing Prints
There are basically two methods of mounting prints – with adhesive or by dry mounting.

Never use ordinary domestic glue, as this may damage the print image. Rubber gum is a safe adhesive, or you might try special spray-on mountant. Other methods include double-sided tape and album corners. Before mounting, trim the picture to the required size with a sharp knife. Spread the adhesive over the back of the print and position it firmly on the mount, smoothing it down to release any air bubbles. Rub away any surplus gum around the edge of the print.

Dry mounting is a clean and effective way of mounting prints. For this, you need a special press, a tacking iron, and some mounting tissue. You tack the tissue onto the middle of the print with the iron, and then trim the print and tissue together. Place the print on the mount, and tack each corner of the tissue onto it to keep the print in place. Then place print and mount

One of the best ways to present your pictures is to mount them, especially for club competitions or exhibition work. Depending on the type of picture and the sort of background it is to be shown on, you can flush-mount it (as left) or use a border to provide a 'frame'.

under the hot mounting press and, with a piece of card laid on top of the print to protect the image surface, apply pressure for up to 10 seconds (depending on press temperature). Remove the print, and, if it has not fully stuck down, apply further pressure.

Filing

Special plastic sheets, or wallets, which hold up to 20 slides (35mm), are available and fit into a ring-binder or can be suspended in an ordinary office filing cabinet. Each wallet can be extracted quickly, and the slides viewed together on a light-box (see below) for easy selection purposes. Keep a record of slides in the file, with exposure and content details.

Some slide projectors use magazines that also serve to store transparencies. Thus slides can be kept in order, ready for projection.

The best way to keep negatives is in a special file that is basically a ring-binder containing sheets for negative strips (35mm or roll-film). Next to each set of negatives can be kept the relevant contact prints for quick and easy identification.

Framing

Good photographs, like good paintings, can easily be spoiled by bad framing. So choose the frame that will show your work to its best advantage. You may decide to mount the print flush onto a wood block, so that there are no surrounds to interfere with the picture's visual impact. Or you might buy a kit (made of metal or wood) to make a frame for the print. Either way, be selective and try to match the mood of the picture if possible.

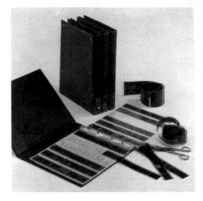
A typical negative file.

Viewing Slides

There are several ways of looking at slides, and you should choose which methods suit your purpose and pocket. They range from hand-held viewers to fully automatic projectors. Most *hand viewers* have battery-powered lamps for table-top viewing, but the ones you just hold up to the light are very cheap and are particularly useful for inspecting slides.

A *light-box* is used for viewing or comparing a number of slides at the same time. Slides are viewed on the diffuse top of the box, over a fluorescent light source.

There are several types of slide projector on the market, mostly designed for standard 35mm slides. The cheapest are the *manual projectors.* You can get *semi-automatic projectors,* with a motorized slide change, or *fully automatic projectors,* most of which feature an automatic slide change via a built-in interval timer. Other projector features include a special built-in *daylight screen,* which is like a small TV screen.

Competition Photography

Many photographic magazines run regular competitions, with a wide range of categories, from sport to architecture, and offer worthwhile prizes.

When a competition is announced, you may already have suitable slides or prints that you can enter. If not, you might like to go out and shoot the pictures specially for it. This is where competitions can be so valuable: they encourage you to go out and take pictures of subjects that you otherwise might not have considered photographing. This will help you to improve your photography, and the possibility of winning a prize – camera, cash, or whatever – is an added incentive.

Remember that the judges will be looking not just for good imagin-ative photography, but for good presentation, too. You might have captured a great shot on film, but if it is badly printed (or, in the case of a slide, badly mounted) it can count against you.

If you are reluctant to part with a treasured slide, you can have a duplicate made. This is relatively inexpensive, and you can even do it yourself with a slide duplicator. Duplicates are also useful if you wish to enter the same picture in several different competitions.

Many a successful picture may be snapped by chance. Here the photographer was alert when the child turned round. The fact that the little girl really stands out against the adults won the picture first prize. Judy Morrison.

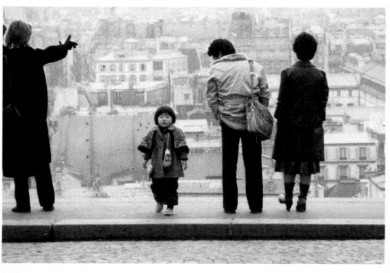

Right: This shot of a bouncing birthday baby won the photographer £1,000 in a competition and has also been reproduced many times since. The theme for the competition was 'happiness' and it is clear from the smile on the baby's face that the picture fitted the category perfectly. Ken Fairhead.

(Photographs courtesy of Amateur Photographer magazine)

Competition Tips (for magazines)

1. Read the rules carefully. If you fail to observe them, you will probably lose all chances of success. For example, if you are asked to send in only black and white prints and you send in colour, you are likely to be disqualified immediately. Points like this are important – so read the small print before entering.

2. Always enclose a stamped, addressed envelope if you want your material returned. If you don't include postage, the photographs may well be kept on the magazine's files.

3. Put your name and address clearly on every print or transparency entered so that they can easily be identified. Although most magazines take great care when handling material, pictures sometimes go astray. If necessary include any details about the pictures (when and where taken, exposure, and so on) on the back of the print, or on a separate sheet of paper.

4. Don't submit glass-mounted slides. If the glass breaks during carriage, the slides may be damaged – and they can be a hazard to anyone opening the package. To protect the slides, pack them in a slide box (usually supplied with processed film) or shield with thick card and send them in a padded envelope.

5. Mark clearly on the envelope the title of the competition you are entering – some photographic magazines run several competitions at once.

6. Copyright of all entries remains with the photographer – avoid competitions where this is not the case. Where no prize is awarded to the photographer, a fee should be paid if the entry is used in the magazine.

Glossary

Aperture Size of the opening in the lens diaphragm. Controls light entering the camera.

ASA (American Standards Association) Rating of film emulsion speed, or sensitivity to light.

Bellows extension Sleeve placed between camera and lens for close-up photography.

Bracketing Taking additional shots at one stop above and below the recommended exposure.

Cable release Short cable which screws into the camera shutter release button. Helps to prevent camera shake.

Colour temperature Measurement of the colour quality of a light source. Expressed in *degrees Kelvin.*

Compact Term normally used to describe a small 35mm direct vision camera.

Compact: A recent refinement of the 35mm compact principle, this Hanimex is not a direct vision camera, but features reflex viewing and focusing. So there is no separate viewfinder, viewing being through the lens. In addition, this compact par excellence *features built-in flash.*

Definition Clarity of a photographic image. Considerations include sharpness, lens resolution, graininess, contrast, and tone.

Depth of field The area in front of, and behind, the point focused on which will be acceptably sharp.

Depth of focus The distance that the film plane can be moved while retaining a sharp image without re-focusing the lens.

Developer Chemical that converts an invisible latent image into a visible form.

Diaphragm The adjustable blades inside the lens which determine the aperture.

DIN (Deutsche Industrie Norm) German alternative to ASA for measuring emulsion speeds.

Double exposure Exposing the same piece of film, or photographic paper, twice.

Emulsion Light-sensitive coating (consisting of silver halides in gelatine) on films and printing papers.

Exposure The intensity of light reaching the film (controlled by lens aperture and shutter speed).

Extension tubes Metal tubes which fit between camera and lens to extend focusing range for close-up work.

Film speed Measurement (in ASA or DIN values) of a film's sensitivity to light.

Filter Transparent material (usually glass) which is specially coated to affect the light passing through it.

Filter factor The amount by which exposure has to be adjusted to compensate for the light absorption of the filter.

Fish-eye lens Extreme wide angle lens.

Fixing Processing stage where the film, or print, is stabilized and no longer affected by white light.

Flare Light scattered by reflections within the lens or camera.

f-number (or f-stop) Denotes size of opening of the lens aperture as marked on the lens; equivalent to focal length divided by aperture diameter.

Focal length Distance between the rear *nodal point* of the lens and the *focal plane,* when the lens is focused at infinity.

Focal plane The plane on which a sharp image is focused by the lens.

Focal plane shutter Shutter system situated at, or near, the focal plane.

Grade Measurement of paper contrast, from soft (0) to very hard (5).

Grain Exposed and developed *silver halides* which produce the visible image.

Guide number Numerical factor which gives a guide to correct exposure when using flash.

Halation Diffused image caused by light reflection inside the camera.

High key A picture which has large areas of light tones, with few dark tones.

Highlights Bright areas of the image shown as dense areas of black metallic silver on the negative.

Hypo Common name for a fixing agent.

Incident light Light falling onto an object, not light reflected by it.

Infinity In photography it relates to most objects seen beyond 1,000 metres. It is the farthest focusing mark on the lens.

Infra-red Rays at the red end of the electro-magnetic spectrum, invisible to the human eye. They can be recorded on special films, producing unusual images in black and white and colour.

Iris diaphragm Adjustable lens aperture made up of metal leaves.

Latitude The amount that exposure can be varied and still produce an acceptable result.

Line image An image that has only black and white areas, ie no grey mid-tones.

Long focus Used to describe a lens with a focal length longer than the diagonal length of the film format in use.

Low-key A picture in which the tones are decidedly dark, with few light areas.

Mirror lens A lens which has mirrors in its internal construction. This type of lens offers a long focal length inside a short barrel. The light rays are reflected inside by mirrors.

Negative An image made on an emulsion by exposure and development. Tones appear reversed, ie, light as dark, dark as light.

Neutral density filter Fits over the camera lens to reduce the amount of light reaching the film. Useful when shutter speed or lens aperture cannot be adjusted.

Normal lens Lens which has a focal length about equal to the diagonal length of the film format in use.

Open flash Method of making an exposure with a flash without connecting it to the camera.

Orthochromatic Describes an emulsion sensitive to blue and green, but not to red, light.

Panchromatic Emulsion sensitive to all colours of the visible spectrum and to certain ultra-violet light.

Parallax The difference between the image seen through the camera viewfinder and that recorded on the film.

Pentaprism Optical device found usually in 35mm cameras which enables through-the-lens viewing of the subject via a 45° mirror.

Photoflood Artificial light source using a tungsten lamp and reflector.

Plate camera Camera that uses glass photographic plates.

Polarized light Rays of light that vibrate in one plane only.

Rangefinder Coupled focusing system found in some 35mm cameras.

Reflected light reading Measurement of light reflected from the subject.

Reflex camera Camera that features an internal mirror to reflect light coming in through-the-lens onto a viewing screen.

Safelights Special darkroom illumination to which certain photographic materials, particularly papers, are insensitive.

Shutter Mechanical system used to control the amount of light reaching the film, thus affecting exposure.

Silver halides Light sensitive particles used in photographic emulsions.

Speed A film's sensitivity to light, expressed in ASA or DIN numbers.

Stop bath Chemical bath used to stop development.

Synchro-sunlight System of using daylight and flash simultaneously to light the subject.

Telephoto lens A long focal length lens

Toners Used to change the colours of a print chemically for effect.

Transparency A positive image made on transparent film.

Tripod Camera support with extending legs and adjustable head.

TTL Through-the-lens, refers to viewing and metering system found in SLR cameras.

Uprating Increasing the film ASA rating to cope with low lighting conditions.

View camera Large format camera with large ground glass viewing screen.

Viewfinder Used for viewing, and sometimes focusing on, the subject.

Vignetting Technique where the borders of a print are faded out for effect.

Wetting agents Usually added to the final wash of films to prevent drying marks appearing on the emulsion.

Wide-angle lens A lens with a wide viewing angle. It has a focal length shorter than the diagonal of the film format in use.

Zoom lens A lens with an adjustble focal length.

Index

ACKNOWLEDGEMENTS

Heather Angel 94BL; David Bailey 102; Norman Barrett 61T & C, 89TL & TR; Phil Brown 89C; Patrick Lichfield/Camera Press 11BL, 77, Lord Snowdon/Camera Press 79; Cannon 20; Bruce Coleman 11BR, /Stephen Dalton 13T, 95; Colorsport 86; Colram Photographic Agency 99; Gerry Cranham 40; Tom Dudd 33T; Patrick Eager 87BL; Ken Fairhead 121; W. Gale 66; Sonia Halliday 10B, 13B, 56T, 57, 58B, 59, 60, /F. Birch 64; 82B, 83, 88, 91T, /F. Birch 92C, /F. Birch 103T; Hasselblad 23; Hong Kong Government Tourist Office 85T; Jean-Pierre Horlin 81T; HOYA 12B, 68, 70, 71BR; Kodak 25BR, 27C; Konica 18; E. Lacey 87T; Alan Mcfaden 12T, 29, 100T; Minolta 26; Judy Morrison 120; Pentax 25T; Polaroid 27T; Geoff Prestwich 71BL, 76C, 91TL & BR, 101BL; Mervyn Rees 46; Rolleiflex 22; Alfred Spencer 90, 93; Richard Summersby 76BL; Syndication International 33B; A. Sieveking/Vision International 80, 81B; ZEFA 8, 11T, 30-31, 61B, 75, 78, /Reinhard 82T; 84, 97TR, 98;

Cover: John Shires

All other pictures supplied by the author, Barry Monk

B = Bottom; T = Top; L = Left; R = right; C = centre

Artwork by Brian Watson (Linden Artists)